IMAGES
of America

SPRINGFIELD TOWNSHIP, DELAWARE COUNTY

Happy Mother Day
2005

All our love

Rick & Bonnie

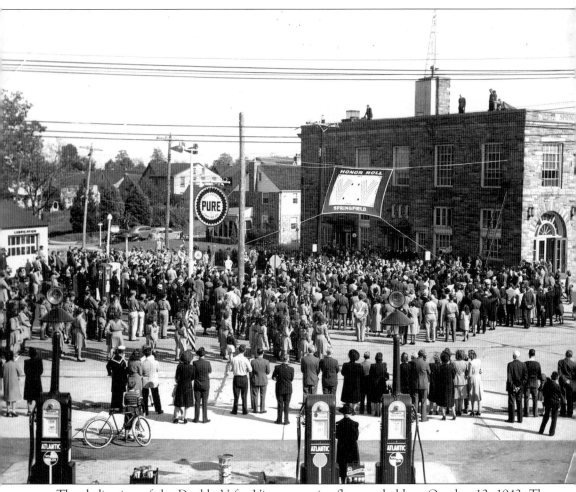

The dedication of the Double-V-for-Victory service flag was held on October 12, 1942. The ceremony took place at the Springfield Township Building, at Saxer Avenue and Powell Road. The high school band led the parade, which consisted of Boy and Girl Scout troops, members of the American Legion and Auxiliary, the Red Cross, and the local civil defense organization. The blue stars represented the 227 Springfield men and women serving in World War II. The two gold stars were for Jack Hoffman and Karl Olle Wallden, who lost their lives. Harry's Tailor Shop, on Saxer Avenue, cut out all of the stars. Every month, mothers and wives sewed additional stars on the flag for those entering the armed forces. As 1942 drew to a close, there were 274 stars on the service flag. What happened to this flag after the war? (Betty Lohr Hoy.)

IMAGES
of America
SPRINGFIELD TOWNSHIP, DELAWARE COUNTY

Springfield Historical Society

ARCADIA

First published 2004

Published by Arcadia Publishing,
an imprint of Tempus Publishing Inc.
Portsmouth NH, Charleston SC, Chicago IL,
San Francisco CA

Printed in Great Britain

Library of Congress Catalog Card Number: 2003110676

For all general information, contact Arcadia Publishing:
Telephone 843-853-2070
Fax 843-853-0044
E-mail sales@arcadiapublishing.com
For customer service and orders:
Toll-free 1-888-313-2665

Visit us on the Internet at www.arcadiapublishing.com

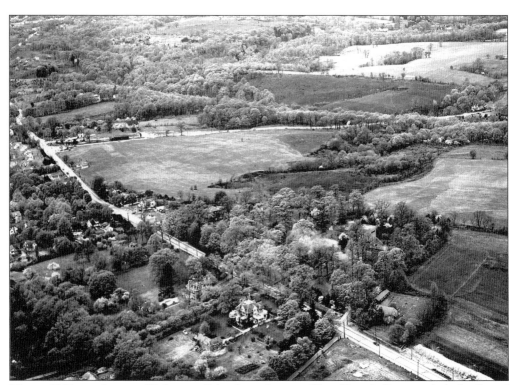

This *c.* 1950 aerial view of Baltimore Pike shows Lownes Blue Church (lower right); the Bartol Building (present site of Springfield Square North Shopping Center); Keystone Business School, located across Baltimore Pike; Lincoln Avenue; Elnwood Nursing Home; and, on the north side, two gas stations and a large field that is part of the Gibbons Farm, located on the northwest corner of Sproul Road and Baltimore Pike. (Media Historical Archives.)

CONTENTS

Acknowledgments

Photographs are an invaluable source of historical information. They provide a unique insight into events, people, and places that might otherwise be forgotten. In that context, this book provides a unique window into the past.

While photographs of the founding families do not exist, the community is privileged to have a photographic record in many instances of where these early settlers lived, worked, and worshiped, along with images of events and activities of many of their descendants and other residents over most of the last century. This collection is a vivid image of the past, enhancing the present and leaving a pictorial legacy for future generations.

Many individuals have contributed their knowledge, talent, and support to this project, and it is the sum of their efforts that has made this publication possible. They include, in alphabetical order: the Robert Wright Broussard family, Barbara and Don Burke, Ted Green, Carl Hough, S. Damon Kletzien, Paul Litecky, Delaware County historian Keith Lockhart, Eileen Mowrer, Betty Naylor, Glennie Shadle, archivist for Sellers Free Library Tom Smith, *Springfield Press* journalist John Taylor, and Evelyn Thomas.

Special thanks go to all of the individuals who contributed photographs to the Springfield Heritage Museum that were not used in this publication due to space limitations. These photographs will be added to the collection and made available for public viewing at the museum. Please call (610) 938-6299 or stop in the museum to see these photographs and the total collection at the Springfield Heritage Museum, 111 Leamy Avenue, Springfield, Pennsylvania 19064.

INTRODUCTION

In the late 1600s, the first settlers arrived in the area now known as Springfield. They found rich, fertile soil, ideal for farming, along with two creeks offering an abundant supply of water. Beds of limestone, which became quarries, and the virgin timber stands of the region provided plentiful building material. These pioneers and those who followed used these raw material to create one of the most appealing townships in Delaware County.

Land grants issued prior to 1700 reflected a mixture of English, Welsh, Scotch-Irish, Dutch, Swedish, and German surnames. Memories of those pioneers are reflected in many of the street names of the township. One of the pioneers was the sole woman on the list of titleholders. Jane Lownes is called "the pioneer mother" of Springfield Township. A widow, she arrived with her four children and spent the first winter here living in a cave dug into the bank of Crum Creek.

The European newcomers had little trouble with the Native American population. The local tribes belonged to the Lenni Lenape family, more frequently termed the Delaware Indians since they inhabited the forested valley along the Delaware River. They maintained several wigwam villages in the Springfield vicinity, with one large settlement on Lownes Run, a small stream flowing into the Crum Creek.

The earliest settlers mostly concentrated on farming, raising crops and livestock, and mills were built to support these efforts. As the community continued to grow, so did the output of the mills. Because getting their goods and the farm produce to markets was important, the planning and building of road arteries marked the early years of the century. Such efforts spawned Darby Road, Springfield Road, and the Delaware County Turnpike, which is known today as Baltimore Pike.

The present boundaries of Springfield do not represent the original town lines. The borough of Swarthmore and the borough of Morton were an integral part of early Springfield until the late 1890s. As the community grew, houses of worship in many denominations were built to meet the religious needs of all of the residents. With technological improvements in transportation, more people from the city, as well as the country, were able to reach, discover, and settle in the community.

Springfield Township emerged from a modest beginning of settlers who were farmers, cattle raisers, tanners, and millers. Today, Springfield is largely residential, and while most of the old farmland in the township has been acquired for building purposes, many park areas have been retained for recreational uses and improvements through the work of the township park board and the efforts of the township government.

Communities like Springfield are an integral part of the bone and sinew of the United States. Such elemental parts of a great country are not created overnight, and this township has been maturing for more than three centuries.

This book offers a brief glimpse of the history, character, and attraction of one of Delaware County's earliest communities. With a proud past, Springfield Township is destined for an even greater future.

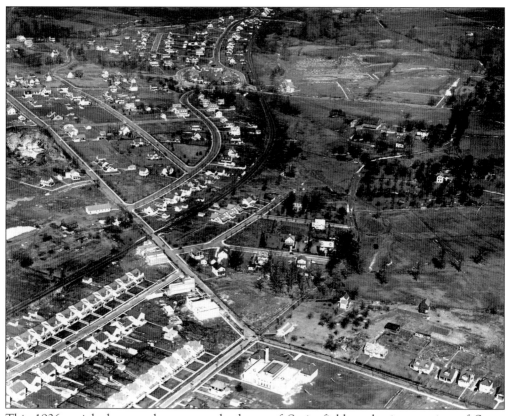

This 1926 aerial photograph captures the heart of Springfield at the intersection of Saxer Avenue and Powell Road, in the lower center, with Central School located just below that. Above the intersection are vacant lots on both sides of Saxer Avenue, where the Wawa and the Sunoco gas station stand today. Continuing up Saxer Avenue, Old Central School is on the right, across from the shopping district. In the left center left, Saxer Avenue crosses the trolley tracks, with Johnston Farm on the left and then St. Francis Chapel and the Johnston Quarry. The Bennett Farm (present site of the Springfield Township Building), at Powell and Springfield Roads, was an elegant estate with an 18-room mansion, formal gardens, a large barn, tenant houses, and a horse racetrack. The farm encompassed the area where Ridgewood, Sunnybrook, and Avon Roads are today. The farm fell into disrepair and was torn down in the 1930s. Bennett Road was named for the family. (Hagley Museum.)

One

VISITING WITH THE
FOUNDING FAMILIES

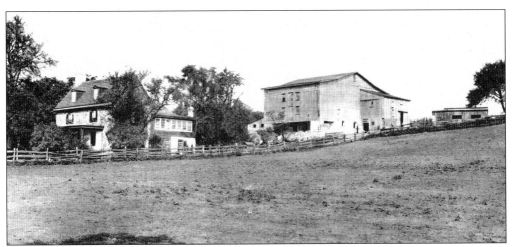

The George Rutherford Farm, pictured in 1930, was located on State Road between Weymouth and West Rolling Roads. Originally built in 1722 by George Maris, it was named Home House, replacing a house built in 1698. A land grant conveyed the property to the Maris family, who lived on the farm until 1901. Maris Road and Rutherford Drive were named in honor of the families. The home was razed in the 1980s. (Jack Rutherford.)

Samuel Levis built this red and black brick checkerboard-patterned home in the late 1680s. The house passed down through eight generations of Levises until the family left the house in 1925. The original kitchen in the basement was believed to be one of William Penn's favorite places to relax when visiting Levises. There is also a tunnel under the house that reportedly was used in the Underground Railroad. (Sellers Library.)

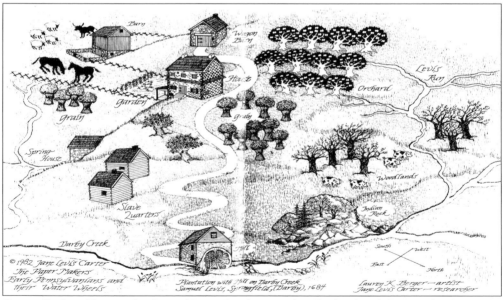

Originally from France, the Samuel Levis family moved to England and then to the Americas, settling this 1,000-acre plantation granted by William Penn. Samuel Levis served in the Provincial Assembly of Pennsylvania, as a member of the Governor's Council, and as a justice of the peace. His grandson Thomas Levis was a member of the Provincial Assembly appointed to draw up the Declaration of Rights at Carpenters Hall. (Map courtesy of Jane Levis Carter.)

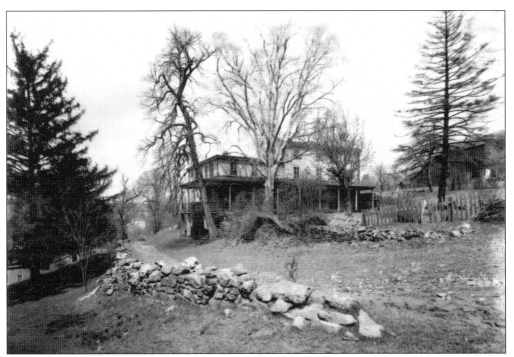

In 1780, the Levis family had this house and mill built on Darby Creek. Both were purchased in 1845 by Moses Hey and altered into the three-story home seen here. During the mid-1800s, the area around the home was known as Heyville. Features of the house include a ballroom on the first floor, three cellars below grade, and six-over-six windows on the second floor. (Sellers Library.)

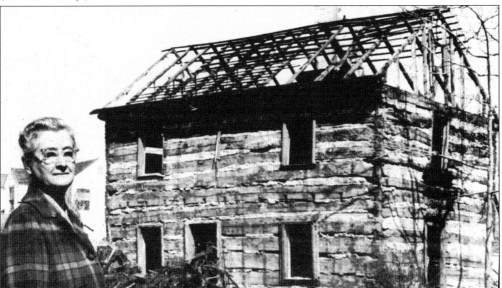

Josephine Albrect, a local historian, looks over the log home she discovered during a renovation in 1964. Originally located on Swarthmore Avenue, the house was built by William Pennock in the late 1700s. After being relocated and reconstructed, it now resides in Upland Borough on the Caleb Pusey property. (Springfield Historical Society.)

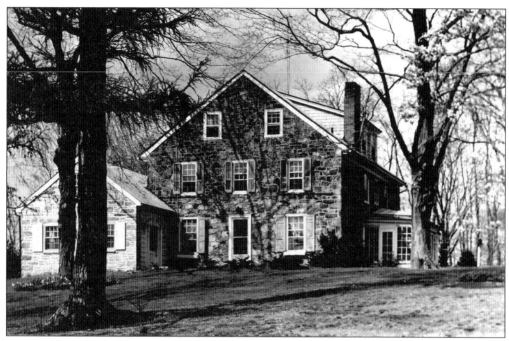

George Maris built this stately Colonial home in the mid-1700s. Constructed from native fieldstone as a rectangular home, the house gained additions in 1790 and 1810 for the second and third floors and, in 1953, for a spacious great room. Chickabiddy Hill, as the home is known, was once the residence of the Saxer and Levis families and was located across Springfield Road from what used to be a racetrack. (Springfield Historical Society.)

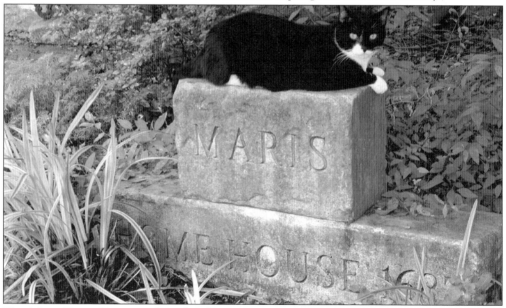

The Maris Home House marker, dated 1683, was removed from the Maris homestead at 400 State Road in the 1980s, during the demolition of the house. At the time, Dee and Bob Wallace were the owners of Chickabiddy Hill, another Maris family home just off of Springfield Road, and made arrangements to have the stone moved to their property. (S. Damon Kletzien.)

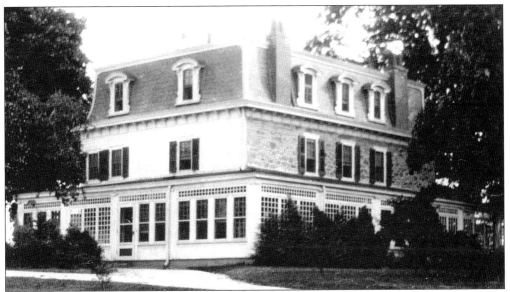

The Joseph Maris Home, photographed in 1930, is located at 421 North State Road. It was built in 1757 on land granted by William Penn. This home has seen many renovations leading to the Second Empire–style façade pictured here. Rumored to have been a stop on the Underground Railroad, it has been visited by many notables, including two presidents. (Jill Zuaguariello.)

Built in 1705 by Richard Maris, this imposing two-and-a-half-story home was in the Maris family until 1787, when it was purchased by the Worral family, who resided there until 1863. Reputed to have been a stop on the Underground Railroad, the home has a tunnel in the cellar that ran under West Rolling Road to a house that is now gone. (Springfield Historical Society.)

Pictured here in 1910 is the Lownes Clovercrest farmhouse, at 321 Woodland Avenue, overlooking Whiskey Run. Built in 1840, this 67-acre farm was located on a property that had been in the Lownes family since 1685. Lownes Lane was named for the family. In 1941, Wick's purchased the property and operated a ski shop there for many years. Many arrowheads and Native American relics have been discovered on the property. (Jane Lownes Shea.)

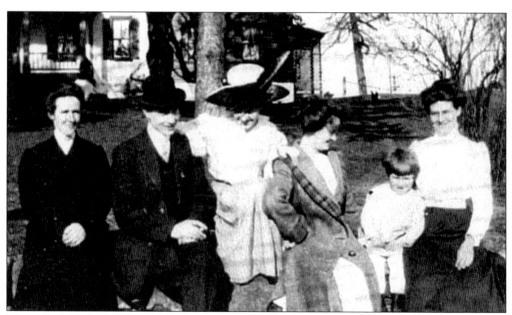

This photograph shows part of the Lownes family in front of the Clovercrest homestead in 1910. The woman on the far right is Jennie Powell Lownes with her son, Joseph. The others are members of the Powell family. The stone wall they are sitting on remains today in front of the property at 321 West Woodland Avenue. (Jane Lownes Shea.)

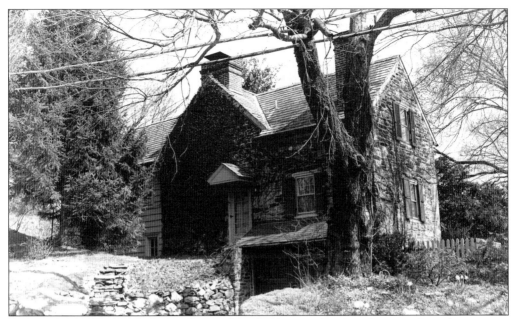

Built in the early 1700s by Daniel Yarnell on land granted to Jane Lownes, Stonelea remains one of the oldest buildings in Springfield. The original house had only two rooms until George Lownes II added a blacksmith forge in the basement and two additional rooms. In 1920, the property was sold by the Lownes family to Emily Pollard, who formally named the home Stonelea. (Springfield Historical Society.)

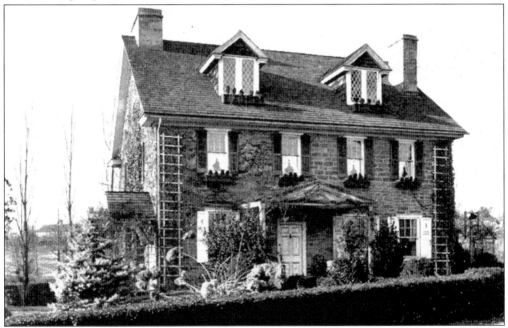

Jane Lownes moved into this home from the cave in which she first lived. Originally one room, the house built in 1684 by her sons has had 27 additions over the years and now totals 24 rooms. On the interior, no two windows are alike and different types of masonry work mark each addition. Today, the home is the rectory for the St. Kevin parish. (Jane Lownes Shea.)

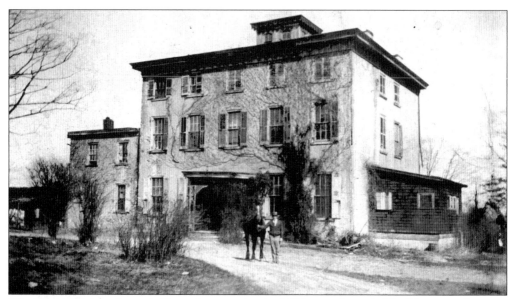

The George Bolton Lownes Plantation consisted of 120 acres bounded by Thomson Avenue, Leamy Avenue, Baltimore Pike, and Powell Road. The 20-room mansion was located close to Thomson Avenue, near Barker Road, with a large quarry on the Woodland Avenue side. George Rutherford, road master for Springfield Township, is pictured here in the 1920s in front of the mansion. The stables on Lownes Farm were leased for a time by Springfield Township. (Jack Rutherford.)

In May 1935, Joseph Lownes moved into the Lownes family home at 225 East Woodland Avenue, which was built in 1900 by his grandfather George Bolton Lownes. Joseph Lownes built this flower shop in 1936 and operated a floral and nursery business until 1986. Lownes Lane was named for this family. (Jane Lownes Shea.)

Happiness House was built in 1751 on Papermill Road by Jane Lownes's grandson. Here, William Garrett operated the Jones Mill, which was powered by the waters of Whiskey run. A raceway ran from the creek under the side of the home. The surrounding area was reportedly once the home of a Native American village. John Turner's house can be seen on the hill. Built in 1763, the house gained an addition in 1787. (Springfield Historical Society.)

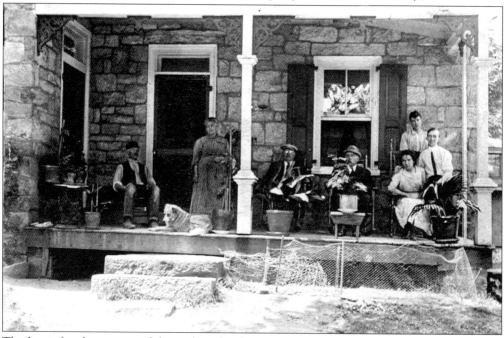

The Levis family was one of the earliest families to settle in Springfield. The girl seated at the right is Gertrude Levis. She later married George Rutherford, who lived on an adjacent farm. The home pictured was originally the Owen Rhoads Home, built in 1824 and located on Southcroft Road. (Jack Rutherford.)

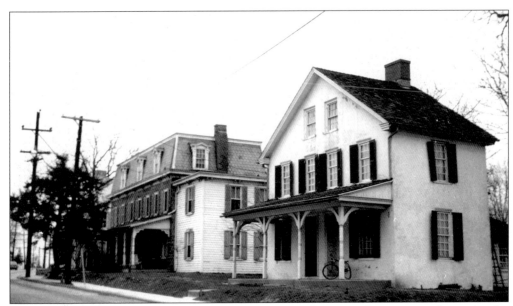

The stone house (left) was built in the late 1700s and was used as a general store and a residence. Its mansard roof was added during the Victorian era, the late 1800s. The house at 801 West Springfield Road (right) was built in the early 1800s, and the Marple General Store was built across the street in 1845. (Springfield Historical Society.)

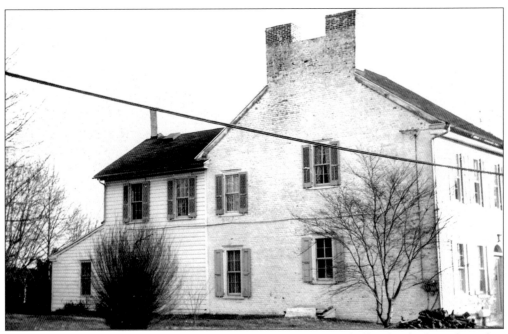

In 1732, Bartholomew Coppock Jr. built this brick house out of ballast bricks from ships that had arrived from England. William Penn deeded the original 446-acre tract of land to Coppock's father. The house was later deeded to Coppock's daughter Esther and her husband, Seth Pancoast. In the early 1800s, the clapboard addition (left) was built. (Delaware County Historical Society.)

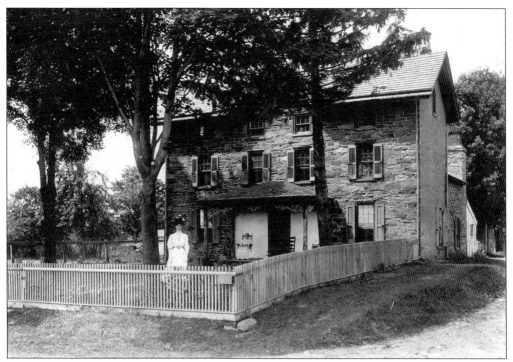

Pictured here in 1908 are Emma Powell and her daughter, Lucy, in the front yard of their home, at 540 West Springfield Road. The house was built by the Rhoads family in the late 1700s on land granted by William Penn in 1682. The Henry Lobb family lived here from 1884 to 1899. Called the Narrow House because of its 14 foot depth, the home today retains many of its original 18th-century features. (Jane Lownes Shea.)

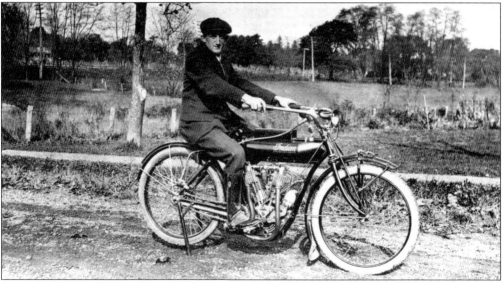

Harry Leedom Lobb was born in 1891 in the Narrow House. He is pictured on his Indian motorbike in 1916. A custodian at Central School, he became a crossing guard there in the 1950s. Rolla Lobb, his daughter, earned placement of the home on the Pennsylvania Inventory of Historic Places in 1975. (Rolla Lobb.)

The Jonathan Taylor farmhouse, located at 119 Harned Drive, first appears on the 1752 Morton map. However, the exact year of its construction is unknown. From 1838 to 1920, Charles and Emma Powell owned and operated the farm. During Prohibition, the farm served as a speakeasy. The large sycamore tree seen here still stands today. (Jane Lownes Shea.)

Members of the Powell family pose on the back porch of the Jonathan Taylor farmhouse c. 1900. From left to right are the following: (first row) Charlie Katz (who later married Carrie Lownes), Mary, and Jennie (who later married Joseph Lownes Sr.); (second row) Carrie, Lucy, and mother Emma Powell. The entrance to the farm was located on Springfield Road where North Britton is located today. (Jane L. Shea.)

This tenant house was part of the Lownes farmland and was sold to Edward and William Lane in 1844. The Lanes operated woolen mills and sawmills and, later, manufactured wagons, rakes, and plows. In 1850, the Holt brothers bought the property and continued the mill operations. Today, this is a private residence, at 518 Prospect Road, and the two-story springhouse is still on the property. (Springfield Historical Society.)

The Blue Ball Inn was built by Mordecai Taylor as a two-room dwelling in 1701. In 1743, Taylor petitioned the county court for a license to operate an inn "on the great road from Darby to Springfield because sometimes twenty to thirty wagons passed in a day." In 1802, the business was moved by Eamor Eachus up the road to the Three Tuns Inn, now the Lamb Tavern. (Springfield Historical Society.)

Built in 1760, the Worrall or Kelso House was home to Capt. Thomas Levis, a fighter in the American Revolution. The original concrete columns, which marked the entrance to the farm, can still be seen at 365 East Springfield Road. Rumor has it that a ghost haunts the attic and that when people try to sleep in the house, their covers are always pulled off the bed by unseen figures during the night. (Springfield Historical Society.)

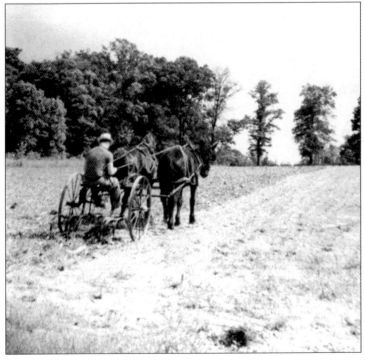

In the 1700s, John Bartram, America's first botanist, presented seedlings of trees as a gift to his friends, the Levises. This 120-acre farm encompassed the area on which Scenic Hills School now stands and extended to Springfield Road. Shown in this photograph is Mr. Kelso working the field in the 1930s. The property was granted by William Penn. (Harry Bornman.)

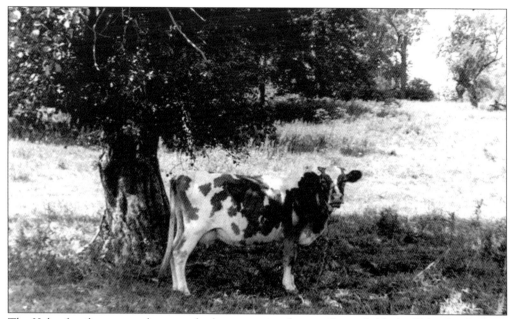

The Kelso family cow was born on the last operating farm in Springfield: the Kelso family farm. More than 100 chickens and assorted numbers of dogs and cats also lived on the farm. Schoolchildren visited the farm every year until it closed. In 1957, an ordinance was enacted that deleted farms from Springfield's zoning code; however, the Kelsos continued farming until the early 1970s. (Harry Bornman.)

This is the Mayer Farm, located on Cascade and Summit Roads. The Ottey family lived in the tenant house on the farm. From left to right are Ellen Ottey, her dog, John Ottey, and father Richard Ottey. The property is now the site of the First Presbyterian Church. (Sandra Oberle Mauro.)

Pictured here in 1937 is the home of Samuel Evans at River View Farm. Joel Evans, father of Samuel, built it in 1820. The Evanses, who were Quakers, farmed the land for four generations until Albert Evans sold the 96-acre property in 1951 for $100,000. Located on the west side of Sproul Road, the land extended to Crum Creek. (Wendell Lofland.)

This photograph from 1940 shows a cabin that was once located on part of the Evans family property alongside Crum Creek. Albert Evans had built the cabin c. 1930 and decided to allow Boy Scout troops from Springfield to use the cabin for camping. (John Talbot.)

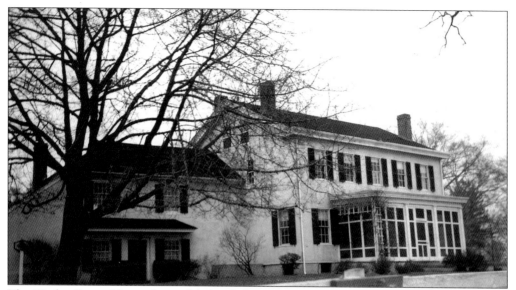

The Taylor-Evans House, located behind the Springfield Country Club, is pictured in the 1960s. The smaller portion (left) was built by Robert Taylor in 1683 and is one of the oldest houses in Springfield. At one time, the house was occupied by Pres. Abraham Lincoln's great uncle (also named Abraham). In 1811, Jonathan Evans purchased the home as a summer retreat and added the larger part of the house. The home remained in the possession of the Evans family for 70 years. (Springfield Historical Society.)

Believed to have been constructed in the late 1600s, the Thomas Fell House was built on land granted by William Penn to Bartholomew Coppock in 1681. In 1718, the title passed to William West, uncle of the famous American naturalist painter Benjamin West, and shortly thereafter, to Thomas Fell. Later owners included Thomas Maddock and Seth Pancoast, who owned the property for 83 years. (Delaware County Historical Society.)

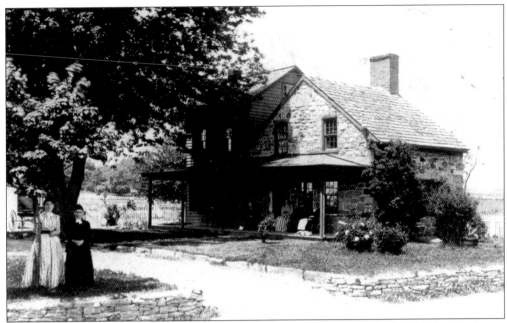

This 1890s photograph shows the Johnston family farmhouse, built in the late 1700s. The house was located on what is now Saxer Avenue between the trolley tracks and St. Francis Rectory. The Johnston family lived here from 1872 until 1948. Joseph Johnston started a dairy farm in 1905 and also had a large quarry operation near Orchard Road. The house was razed in 1968. (Springfield Historical Society.)

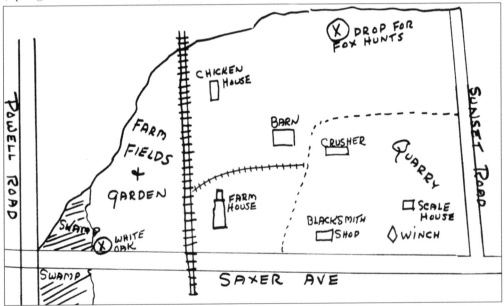

This 1908 sketch shows Joseph Johnston's 21-acre farm and quarry, which extended from Johnston Road (previously Sunset Road) to Powell Road and back to the present high school field. The granite quarry was worked for more than 50 years, ceasing operations in the late 1920s. Siegmund Lubin filmed Wild West movies in the quarry in the early 1900s. The swamps are now the site of a Sunoco station and Wawa. (Springfield Press.)

This 1930 photograph shows four generations of the Pancoast family. From left to right are the following: (first row) Malachi Pancoast holding Bill Pancoast Jr and Ellen Sloan Pancoast holding Franklin Pancoast Jr.; (second row) Bill and Franklin Pancoast. Malachi Pancoast was born in Springfield in 1874. He was elected commissioner in 1915, county prothonotary in 1929, vice-president of the Springfield Building and Loan Association, and a charter member of the Springfield Fire Company. (Marge Pancoast Werner.)

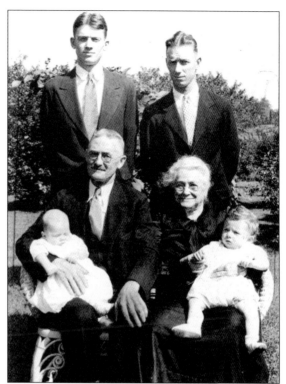

In this view looking north on Leamy Avenue in the early 1900s, the Pancoast Farm is located on the right, and the stream in the foreground is in the area of Evans Road. Built in 1860, the farmhouse still stands at 307 East Leamy Avenue. Malachi Pancoast was one of the founders of the First Presbyterian Church in Springfield. Pancoast and Franklin Avenues were named for this family. (John Traphagen.)

Elizabeth Harris is pictured on the front lawn of the Harris homestead, at 505 East Leamy Avenue. She was an in-law of Mr. and Mrs. Alfred Harris, who moved into the house in 1865 and raised fruits and vegetables for sale in Chester. The 10-acre farm eventually became Harris Nursery. The earliest known date for the house is 1754, as inscribed on the third-floor rafters. (Phoebe Jane Harris.)

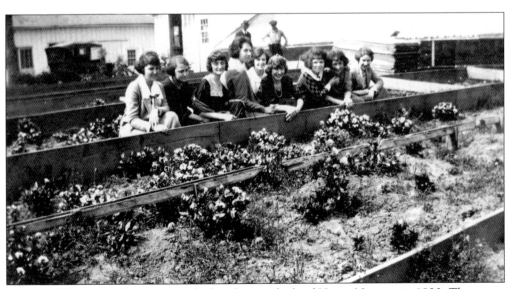

Friends of Elizabeth Harris pose with the planting beds of Harris Nursery in 1920. They were all members of the same sewing circle. The property was sold in 1941, but the old house remains at 505 East Leamy Avenue. (Phoebe Jane Harris.)

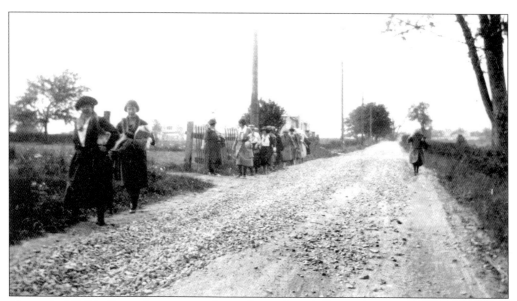

Shown in 1915 is Saxer Avenue as a dirt and gravel road. Down the street is the intersection with Powell Road. These women are walking up from the Saxer Avenue trolley station, past the Spiers home (now on Boxwood Lane), heading to Elizabeth Harris's home, on East Leamy Avenue. (Phoebe Jane Harris.)

Also known as Spring Hill Farm, this 1876 Second Empire Victorian on North Avenue has the distinctive mansard roofline popular in France during the reign of Napoleon III. The house is located just up the hill from the Pennsylvania Railroad Station of Spring Hill, or Secane, as it is known today. The home stands today as a testament to the late-19th-century craftsmen who constructed it. (Keith Lockhart.)

George Shillingford had this fine 14-room stone Victorian house built in 1883 and named it Hillside Cottage. Located at 1150 Blue Church Road, the house had modern amenities that included gas piping and gravitational plumbing, with a 500-gallon cedar water tank on the third floor, which is still there today. In 1911, the Annesley Anderson family occupied the home. Their son, David Anderson, later taught at Springfield High School. (George Trout.)

Pictured in this 1918 photograph are David and Jane Anderson, standing behind their cousins in the quarry on Blue Church Road. They lived directly across the street, at 1150 Blue Church Road. The site of the quarry is now Pennsdale Park. The name Pennsdale comes from the name of J. Edgar Thomson's homestead on Baltimore Pike. (George Trout.)

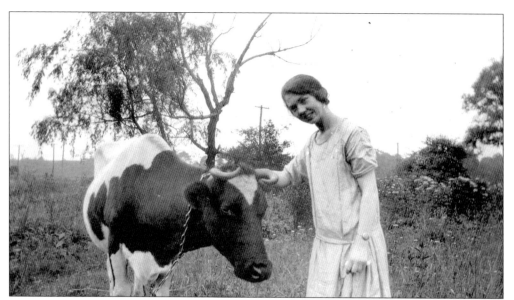

Jane Anderson poses with the family cow at the family home on Blue Church Road in 1920. Her father, Annesley Anderson, farmed the land and raised Rhode Island Red chickens to supplement the family income. He also worked in Philadelphia as a wholesale tea distributor. In the background, telephone poles are visible; however, the home did not have electricity until the late 1930s. (George Trout.)

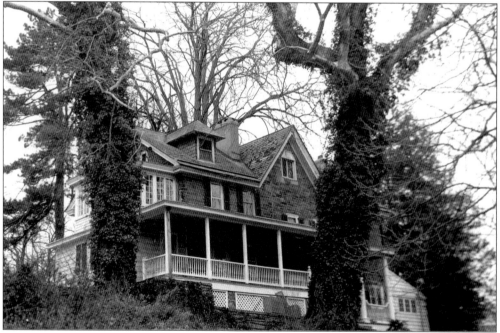

Built on a land grant from William Penn by the youngest son of David Ogden in the 1740s, this stone home retains many of its original details. The house was reputed to be a stop on the Underground Railroad. The first president of Swarthmore College, Edward Parrish, rented the home between 1860 and 1870. Specimen plantings on the property have been attributed to the famous botanist John Bartram. (Springfield Historical Society.)

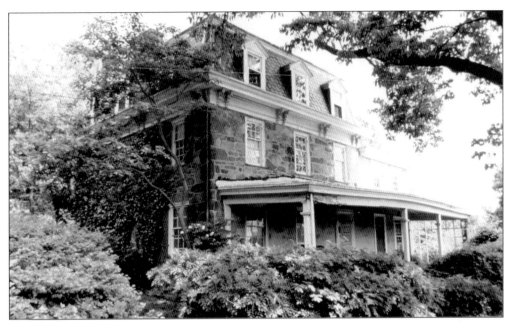

In the 1740s, a modest two-story farmhouse was built on this site by George Maris Jr. The James Rhoads family purchased the property in the late 1700s and retained ownership for nearly 100 years. In 1873, Samuel Hart bought the property and built this Second Empire–style home. The tenant house built by Maris remains attached to this fine example of late-19th-century architecture. (Sandra Oberle Mauro.)

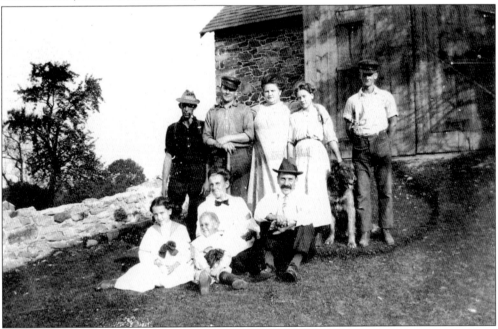

The Ottey family was one of the earliest families in Springfield. Members of the family are pictured at the Bennett Farm, which was on the site of the Springfield Township Building. Ellen and Richard Ottey had 11 children. Over the years, the Otteys worked on many farms in the area and lived in the tenant houses. (Sandra Oberle Mauro.)

Two

MORTON AND
SWARTHMORE

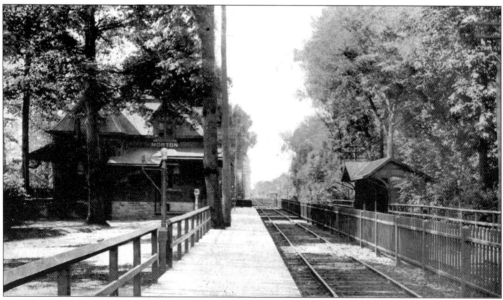

Morton Train Station was originally called Newton Station for Isaac Newton, who owned a large farm in the area. Newton was the first commissioner of the Department of Agriculture under Pres. Abraham Lincoln. The station was built in 1880, and the freight depot was located on the west side of the station. Morton was a section of Springfield until it seceded from Springfield Township in 1898. (Don Burke.)

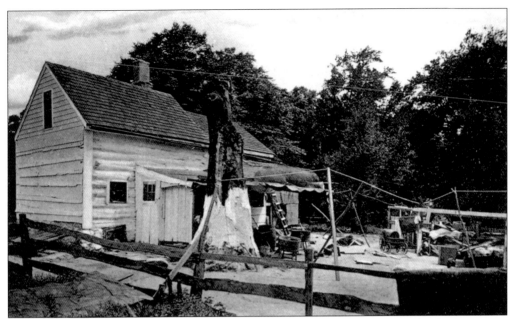

Pictured is a log house, located on Church Road between Christian Street and Yale Avenue in Morton. William Pennock sold this house to John Cummings in 1790. Years later, William Grant bought it and lived there until the early 1900s. The Alva Plastic Printing Company is at this location today. (Don Burke.)

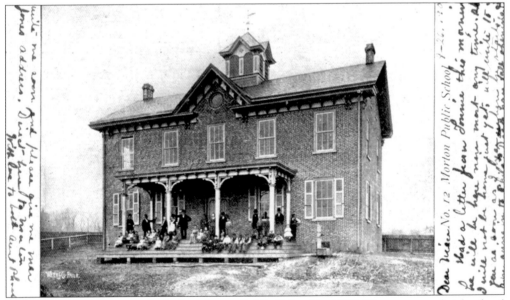

Springfield School District built the Morton Public School in 1876. The two-story brick school was located at the northwest corner of School and Baker Streets. In 1898, Morton seceded from Springfield and the school was given to Morton Borough. Later, it was named Phyllis Wheatley School and was attended only by African American children. (Keith Lockhart.)

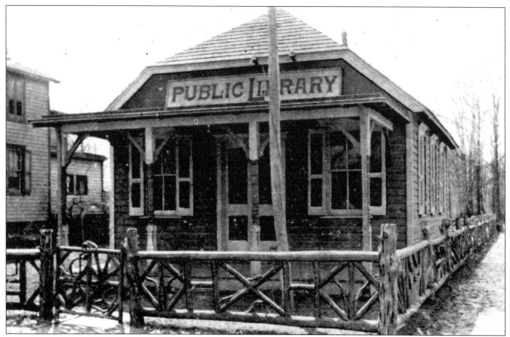

Pictured here is the Morton Public Library. The first library in the Morton section of Springfield, it was in use from 1895 to 1920. This building still stands at the northwest corner of Maple and Walnut Streets and is a private home. (Keith Lockhart.)

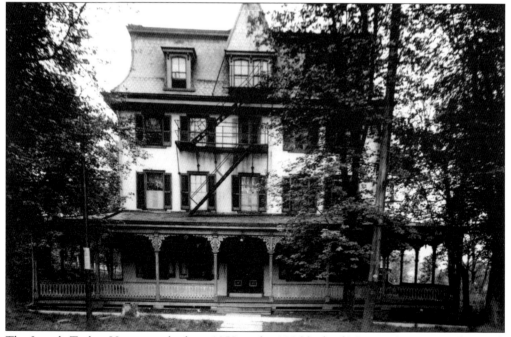

The Joseph Tasker Home was built in 1859 in the 100 block of Morton Avenue on the south side. The home became the Faraday Hotel in 1890 when bought by John Irwin. The hotel was torn down c. 1950. (Keith Lockhart.)

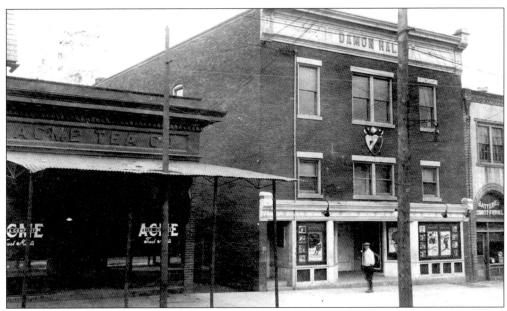

Damon Hall and Theatre was built in 1895 as a meeting hall, with the ground floor used by various businesses until the late 1920s. About that time, the first floor was converted to the Morton Theatre, "Home of the Talkies." This 1920s view shows the hall at 25 South Morton Avenue. Today, Damon Hall is the home of Morton Savings and Loan. (Keith Lockhart.)

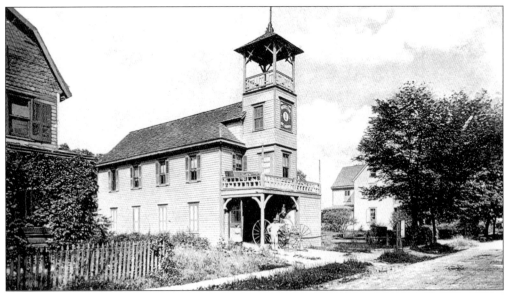

The Morton Fire Company was organized in 1890 with a membership of 50 and was chartered on January 15, 1891, by Judge Thomas J. Clayton. It was the first fire company in what was then Springfield Township. Pictured is the firehouse on the west side of Walnut Street between Maple and School Streets that was used until 1950. (Keith Lockhart.)

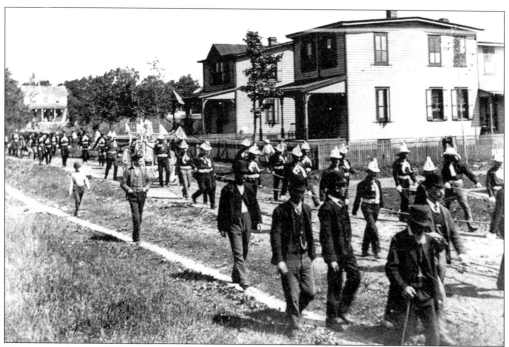

Members of the Morton Fire Company parade on Baker Street near Maple Street in 1892. School Street is half a block behind them. Notice the worn footpath beside the dirt road. (George Shubert.)

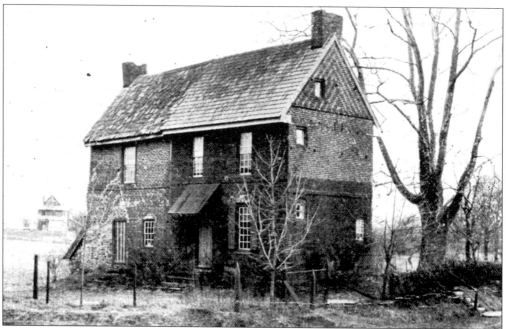

This 1895 image shows the Edwards-Smedley farm, at Morton and Sycamore Avenues. The home was built in 1740 by the Yarnell family. The Edwards family bought the farm in 1839 and lived there for nearly 70 years. The property later belonged to the Smedley family. (Keith Lockhart.)

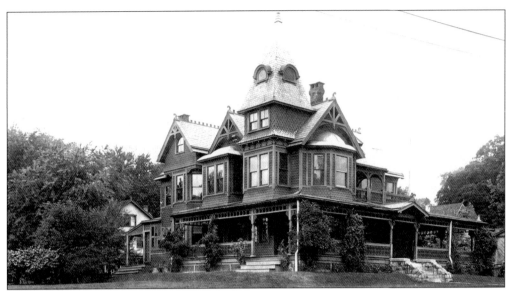

Richard F. Young was a whiskey dealer from Philadelphia who moved to Morton in the 1870s. He built this magnificent mansion in the unit block of South Morton Avenue. The building was torn down *c.* 1950, and the site is now a parking lot. (Keith Lockhart.)

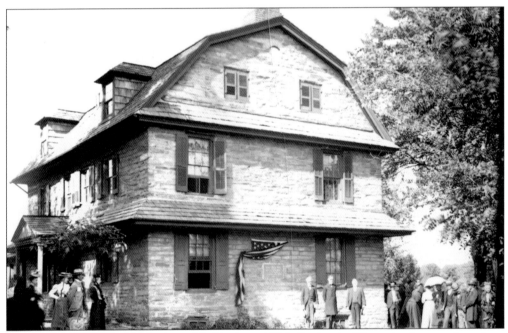

This house was built by Mordecai Maddock in 1714. Benjamin West, the famous American artist, was born in the house in 1738. The area around the house was named Westdale in honor of him. In 1874, the house was purchased by Swarthmore College. Sadly, it burned later that year; however, it was then restored. It still stands on the college campus today. Swarthmore seceded from Springfield in 1893. (Keith Lockhart.)

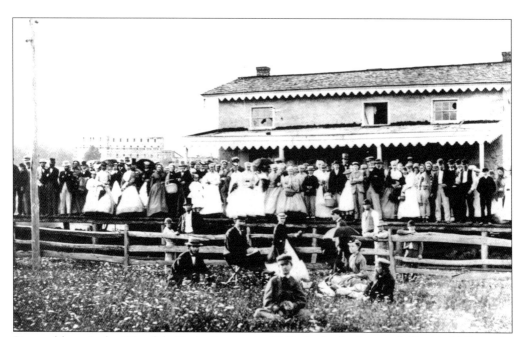

Pictured here is the Westdale Train Station in 1867. In the background, Parrish Hall can be seen under construction. The station was built in 1859 on the Pennsylvania Railroad. In 1870, the name of the station was changed to Swarthmore Station. The current station, erected in 1876 and enlarged in 1903, is still in use today. (Keith Lockhart.)

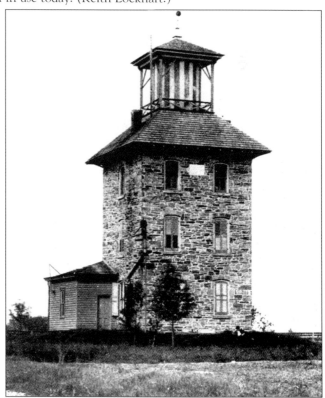

In 1881, the West Hill Water Tower was a small gravity-fed water station, built to supply new homes of the West Hill Land Company. In 1886, the newly formed Springfield Water Company gained control of the tower. Later, the tower was converted into a home for Warren Foote. It remains on the corner of Walnut Lane and Ogden Avenue in Swarthmore. In 1925, the Springfield Water Company was renamed the Philadelphia Suburban Water Company. (Keith Lockhart.)

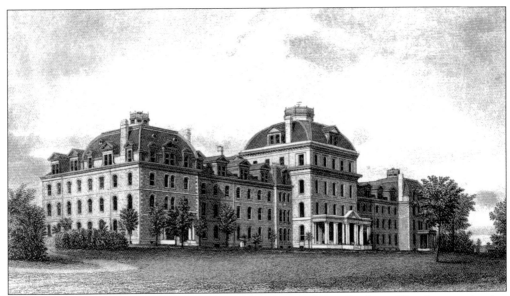

In 1864, Swarthmore College was founded by the Hicksite Quakers. The first graduating class, in 1873, consisted of six students. The building shown was originally called the Main Building and was later renamed for Edward Parrish, the first president of the college. It was damaged by fire in September 1881 and was rebuilt shortly afterward. It still stands today. (Henry G. Ashmead, 1884.)

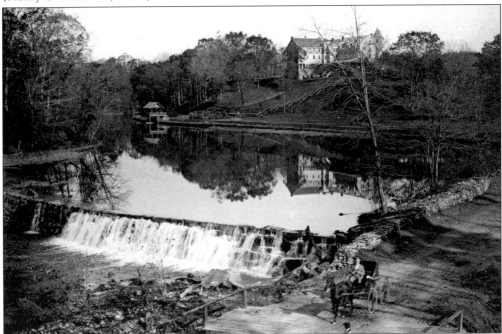

The Strath Haven Inn was built in 1892 as a resort hotel. It sat perched on a hill above Yale Avenue and Crum Creek Falls. The inn closed in 1960 and is now the site of the Strath Haven Condominiums in Swarthmore. The name Strath Haven comes from Thomas Leiper, who owned a tobacco mill on the falls and called the area Strathaven after his hometown in Scotland. (Keith Lockhart.)

Three

SCENES FROM THE
COMMUNITY

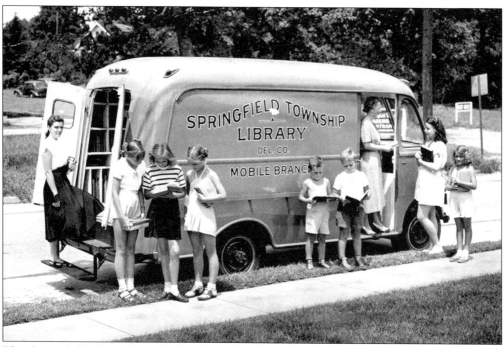

The Springfield Township Library began its bookmobile service in August 1948. Librarian Eleanor Downs in shown inside the front door of the green van. She drove two scheduled routes through Springfield every other Thursday from 9:00 in the morning to 3:00 in the afternoon. This service was in addition to the regular library hours. (Springfield Township Library.)

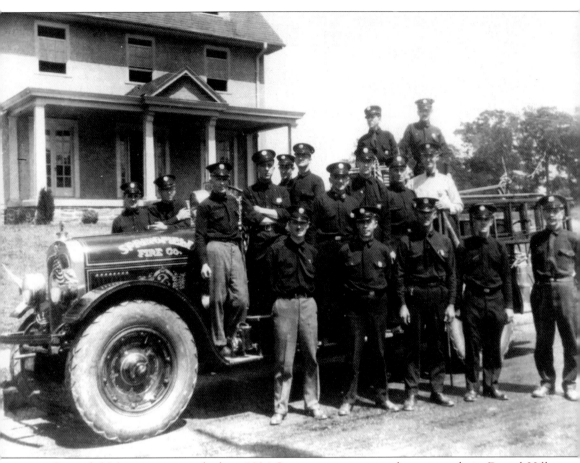

Springfield firemen pose with their 1924 Seagraves pumper truck at a parade in Drexel Hill. They are identified as Earle Holt, Franklin Pancoast, Major Maxwell, Joseph McGee, Roy Haskell, Harry Mumford, George White, Al Gibson Jr., unidentified, Stan Milne, Len Bleyler, Al Gibson Sr., Sherry Waterman, William Smith, William Sockel, Frank Carr Jr., and John Ottey. (Springfield Historical Society.)

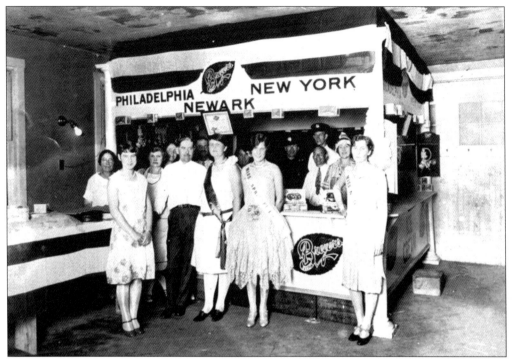

This photograph shows the winners of the Miss Delaware County contest inside the firehouse in September 1927. Cathryn Goheen (center) of Springfield won the title and a 1928 Essex sedan. Carolyn Mitchell (left) of Secane won a $400 diamond ring. Mabel Gibson (right) of Springfield won a $100 diamond ring. Profits exceeded $2,000, with over 6,000 people attending the three-night fund-raiser for the new firehouse. (Springfield Historical Society.)

This photograph was taken in 1927 in front of the new firehouse, at the corner of Saxer Avenue and Powell Road. Notice the original frame firehouse (far right). Among the men pictured with the 1924 Seagraves pumper are Police Chief Harry Kreinbihl (first row, fourth from the left) and Fire Chief Harry Mumford (second row, right). (Dolly Hoopes.)

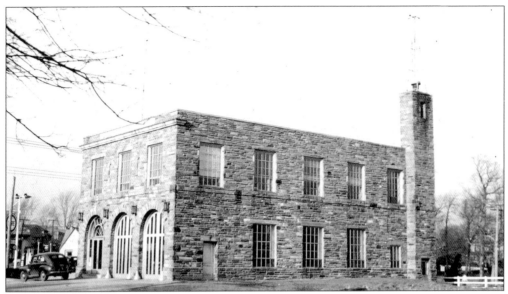

This 1940s view shows the Springfield Township Building that was located on the corner of Saxer Avenue and Powell Road. It was built by the fire company in 1927 and was transferred to the township in 1934. The police station entrance was on Powell Road, with the jail cells in the basement. The fire company occupied the remainder of the first floor, and the township offices and the library had the second floor. (Don Burke.)

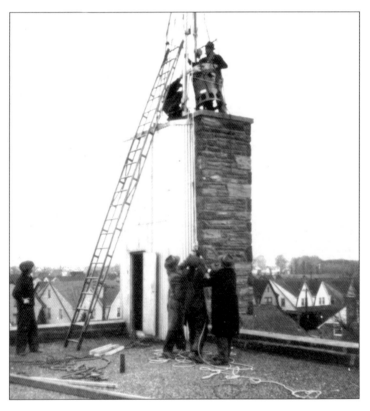

With America's entrance into World War II in December 1941, Springfield ordered five air-raid sirens. The one shown here is being installed atop the Springfield Township Building in February 1942. The four other sirens were installed around the township. The signal for an air-raid warning was a series of short blasts over a two-minute period, and the all-clear signal was one long blast for two minutes. (Harry Bornman.)

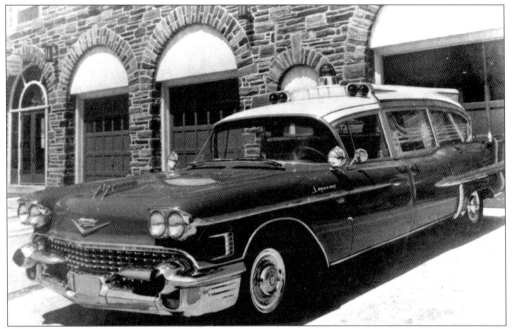

Springfield's ambulance service began in September 1948. Residents and businesses contributed more than $8,000 for the first ambulance. Pictured here is the ambulance that was in use in 1958. The Springfield Ambulance Corps is a volunteer service to the community. (Springfield Historical Society.)

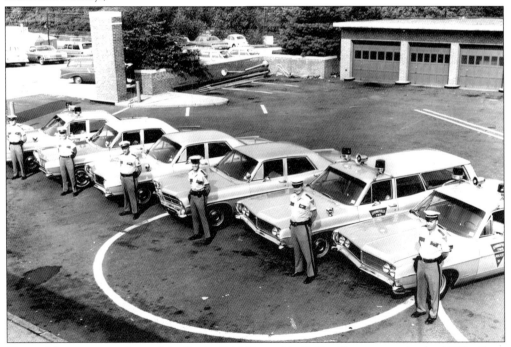

Pictured here are members of the Springfield Township Police Department in the 1960s. From left to right are John Francis, Chief Les Forrester, Sgt. John Chrinka, William Clark, John Foley, and William McCoy. (Springfield Township Police Department.)

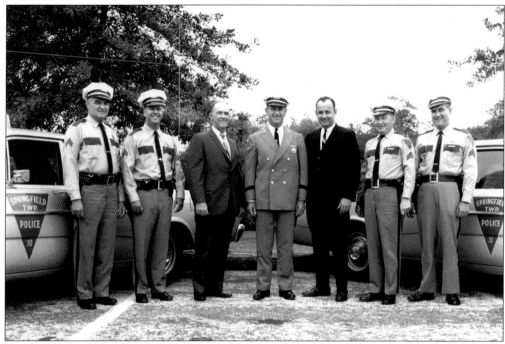

This photograph shows members of the 1966 Springfield Township Police Department posing in front of two squad cars. From left to right are Sgt. John Hedl, Sgt. Harry Hoath, Det. Sgt. Ted Ward, Chief Les Forrester, Det. Sgt. George Hill, Sgt. Clarence Orr, and Sgt. John Chrinka. (Springfield Township Police Department.)

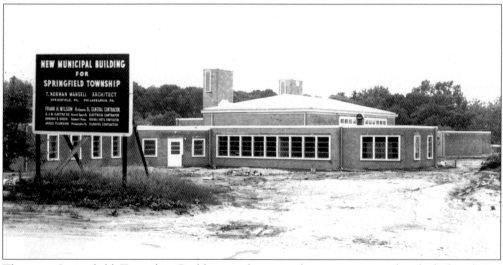

The new Springfield Township Building is shown under construction shortly before being dedication on September 24, 1955. The commissioners at the time were Larry Williams, Kimber Vought, Charles Ludman, Louis Wagner, Bill Stetson, James Davis, and Joe Frank. This property was originally the site of the Bennett Farm, which was razed in the mid-1930s. (Springfield Historical Society.)

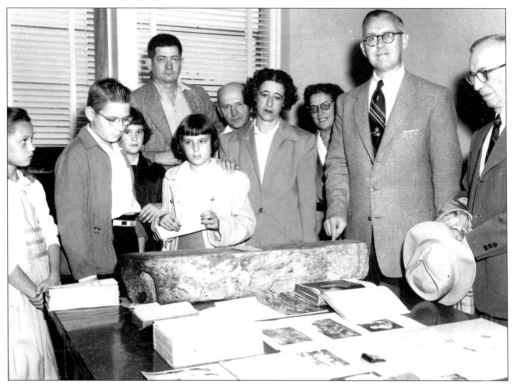

James Davis (second from the right), township historian and commissioner, shows residents artifacts from the township museum. The photograph was taken at the dedication of the new Springfield Township Building, at 50 Powell Road, in 1955. (Springfield Historical Society.)

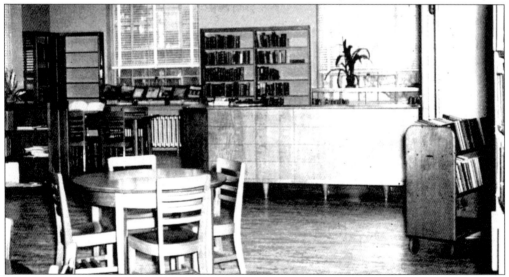

This 1955 photograph shows the interior of the newly renovated Springfield Township Library. The entire second floor of the firehouse was now available to the library, since the township had moved its offices to the new building down the street. One of the most noted improvements was the installation of a dumbwaiter to load and unload books for the bookmobile. (Springfield Historical Society.)

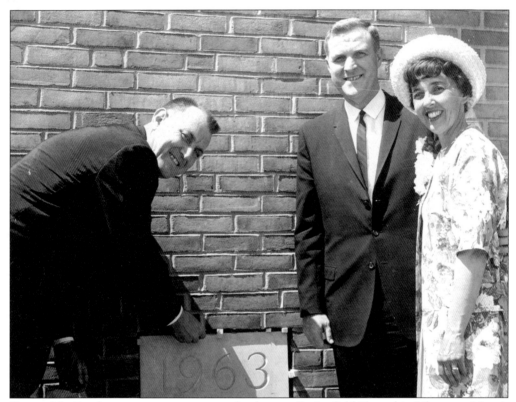

Pictured during the cornerstone ceremony for the new Springfield Township Library on May 4, 1963, are, from left to right, Larry Williams, president of the Springfield Board of Commissioners; Raymond Shafer, lieutenant governor of Pennsylvania; and Winnie Vaules, president of the library board. Williams Park was named in honor of Larry Williams. (Springfield Township Library.)

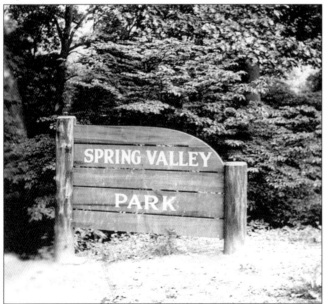

Spring Valley Park, on Leamy Avenue, was formally named in May 1948. School students entered the contest to name the park. The winning name was submitted by Barbara Willits of Springfield High School, and she was presented with a $5 award. She graduated in the class of 1951. (Barbara Willits Maynard.)

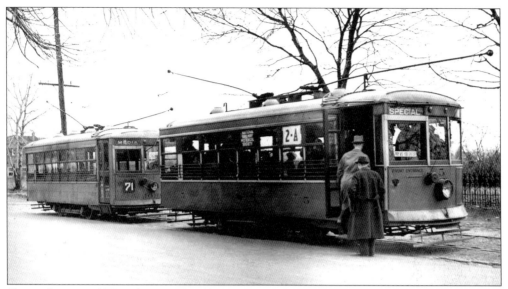

Shown here in 1937 is the No. 5 trolley car running as a Railway Historical Society special. Passengers hurriedly reboard after disembarking to have their photograph taken. Note the topcoats and grand hats that were typical of the day. The No. 71 trolley (left), in regular service to Media, waits patiently for the No. 5 car to move on to the Springfield switch on Yale Avenue. (Stan Bowman.)

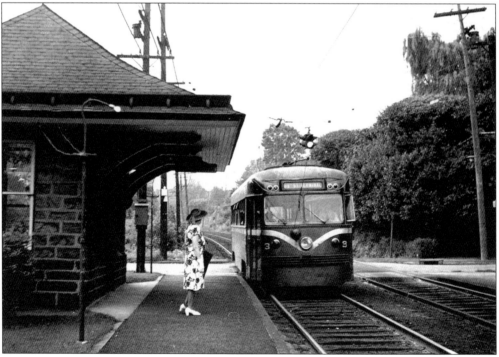

Taken in late summer of 1948, this photograph shows a fashionably dressed Springfield resident at the Scenic Road stop, waiting to board the Media line's No. 3 trolley, a Brill car. This line ran all the way to 69th Street. Note the substantial overhang on the station roof, affording trolley riders cover during inclement weather. (Railroad Avenue Enterprises.)

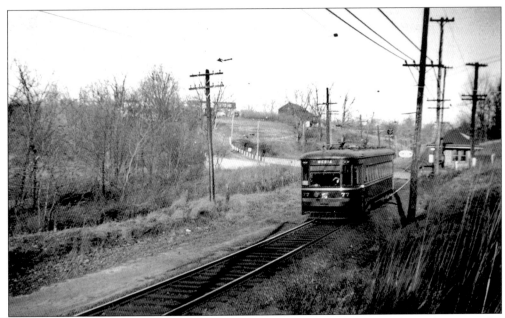

A Media local, the No. 77 car stops at Chester Road (now the Sproul Road stop at the Springfield Mall) and then heads downgrade toward Smedley Park. The operator has the sunshade set low as this late December 1934 day draws to a close. In the early 1950s, the Pennsylvania Highway Department built a concrete span over the trolley line and Whiskey Run. (Bob Morris.)

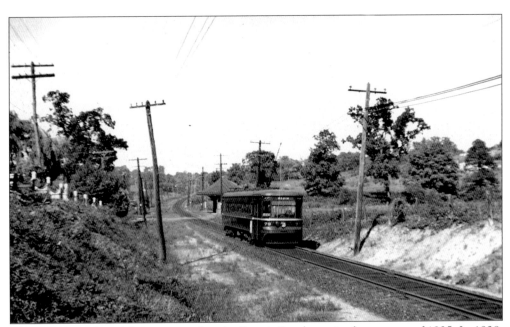

The No. 79 car from Media approaches the Scenic Road stop in the summer of 1935. In 1928, the Philadelphia Airport Authority proposed plans for an airport on the Scenic Road plateau, to the right and up the hill from this stop. In the background, the tracks curve east and pass over Darby Creek on a trestle as the line heads into Upper Darby Township. (Bob Morris.)

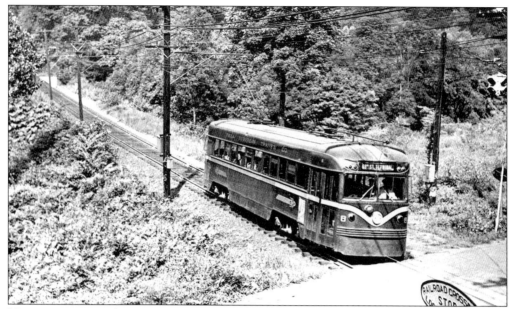

Having just crossed Crum Creek, Philadelphia Suburban Transportation Company's Red Arrow No. 8 car begins the long ride upgrade into the heart of Springfield. The line, single tracked at this point, rises over 150 feet from Whiskey Run to its summit at Saxer Avenue. This photograph was taken in the early fall of 1948 at the Paper Mill Road stop. (Pennsylvania Trolley Museum.)

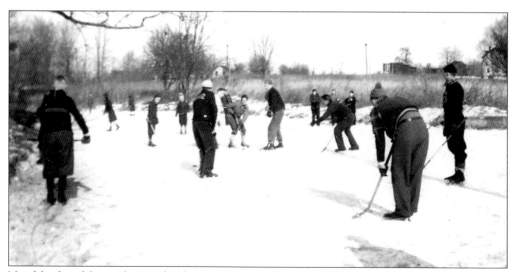

Neighborhood boys play ice hockey on Sloanies Pond in 1938. Among them are Joe Nulty, Robert Smith, Edgar Masson, Harry Bornman, George Tallman, James Beggs, and Bill Hoath. The pond was located at the end of Franklin Avenue between Saxer and Leamy Avenues. (Edgar Masson.)

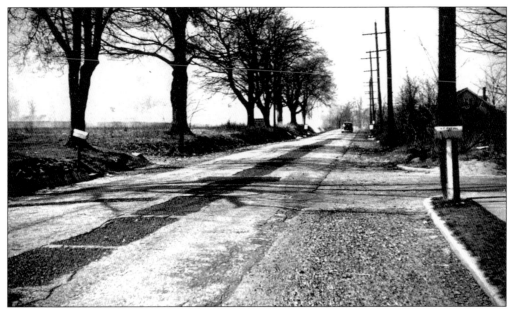

This photograph, taken looking north in the 1940s, shows Springfield Road. The mailbox on the left is for the Rhoads House, at 540 West Springfield Road, which dates back to the late 1700s. The field next to the Rhoads House is currently the site of Springfield High School's Halderman Field. (Bud Aikman.)

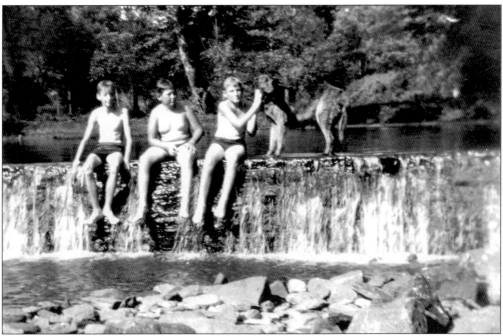

On the dam at Crum Creek in July 1935 are, from left to right, James Beggs, Robert Smith, George Tallman, and Bill the dog. This was the boys' annual camping trip. The campers slept in tents and cooked their own meals for a week. Also at the campsite were Edgar Masson, Harry Bornman, and Bing the dog. One of the parents picked up the campers at the end of the week. (Harry Bornman.)

Ed Tuttle, scoutmaster of Springfield Boy Scout Troop No. 5, leads the Scouts along the 200 block of Powell Road. Scout Troops Nos. 1, 3, 4, and 5 are all pictured in this photograph of the 1940 Memorial Day parade. (Barbara Willits Maynard.)

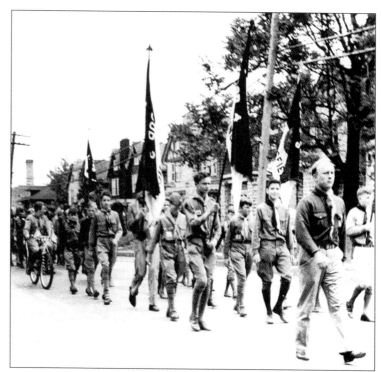

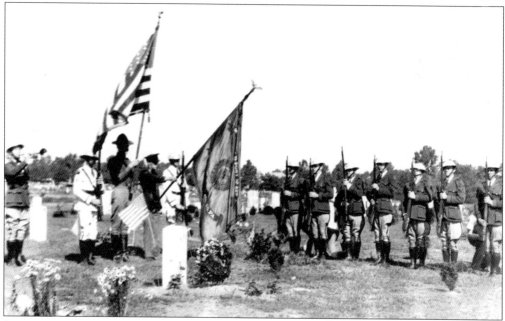

Legionnaires stand at attention while taps are blown over the grave of Hobart Austin at Holy Cross Cemetery on Memorial Day 1932. Traditionally, members of Springfield's American Legion Post 227 visited three cemeteries on Memorial Day. From left to right are bugler ? Marshall, Dave Thompson, Major Turner, John Franks, Homer Carter, Arthur Rann, John Kelleher, Edward Raymond, Charles McGravey, George I. Boyd, Frank Eby, and B. Slack. (Springfield Historical Society.)

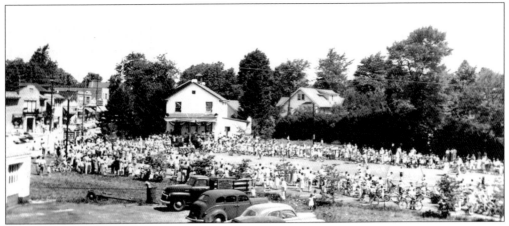

Shown is the 1952 Fourth of July celebration at the Old Central Schoolhouse, on Saxer Avenue. The American Legion sponsored the parade and activities, which included competition for baby carriages, bicycles, and floats, as well as races and a chicken-catching contest. The American Legion gave out free ice cream, a ball, and a flag to everyone. (Dotty Lou Rose.)

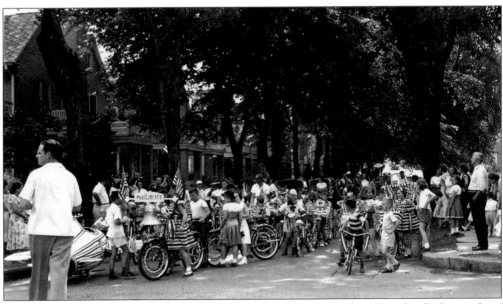

The children of Springfield assemble in the Brookside Road area for a Fourth of July parade in the late 1950s. Originally, Saxer Avenue was the only site for Fourth of July celebrations. As the town developed, different sections of Springfield began to have their own community celebrations. (Edgar Masson.)

The Lions Club of Springfield annually sponsored a circus visit to the town. This advertisement was for the Hunt Brothers Circus visit of Thursday, May 17, 1962, at Memorial Park. Admission was $1.25 for adults and 75 cents for children. This was only one of many events sponsored by the Lions Club to raise funds for local charities. (*Springfield Press.*)

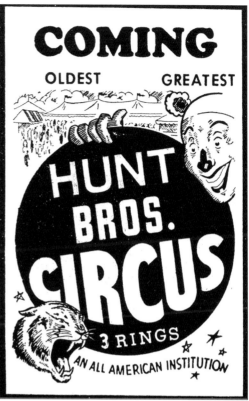

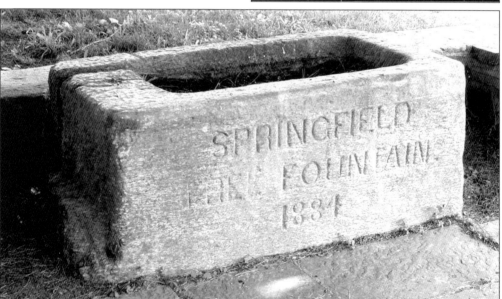

The Springfield Free Fountain Society was formed at the Ogden Home in April 1882 for the purpose of supplying water to humans and animals traveling down the dirt roads. The first stone trough was placed on State Road opposite the George Maris property, with water piped in from a never-ending spring on the Maris property. Now located in Wagner Park, this 1884 trough was donated by George B. Lownes. (Springfield Historical Society.)

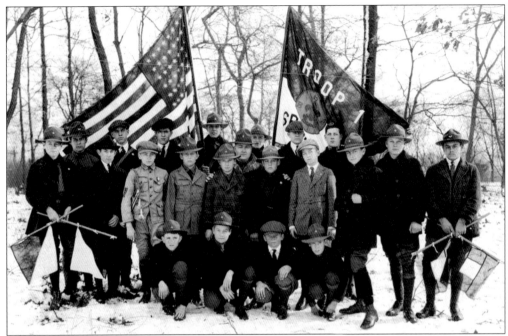

The first Scout troop in Springfield, Boy Scout Troop No. 1 (now Troop No. 110) was organized in 1921 with 12 boys. The troop was sponsored by a group of citizens, with Raymond Cavender serving as scoutmaster. Many more troops were organized over the years, including the Sea Scouts and Air Scouts. (Carl Hough.)

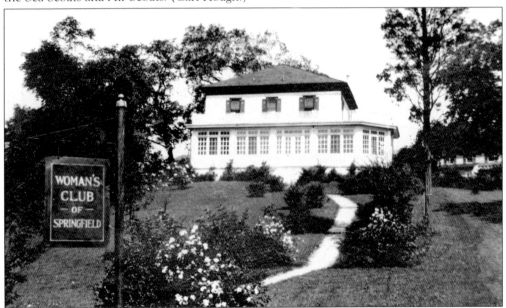

The Woman's Club of Springfield began on January 5, 1918, with a tea party at the home of Mrs. William Allison. In 1923, with Mrs. Carter as president, the club purchased and remodeled as its clubhouse the old Saunders property, shown here in the late 1930s, overlooking Windsor Circle. The building is now a private residence on Cascade Road. (Springfield Woman's Club.)

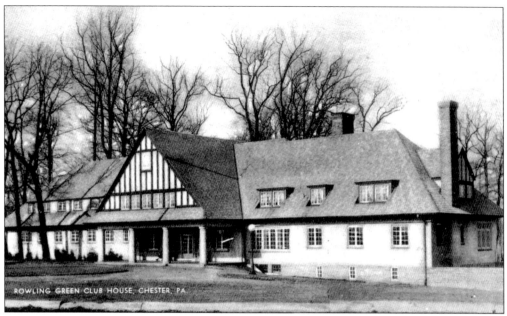

The Rolling Green Country Club was built on land originally owned by George Maris. The club purchased the property in 1924 and held a dedication ceremony on September 18, 1926. Rolling Green Country Club is located on Northcroft Road. The Richard Maris house, which was built in 1720, remains today at the 12th green. (Don Burke.)

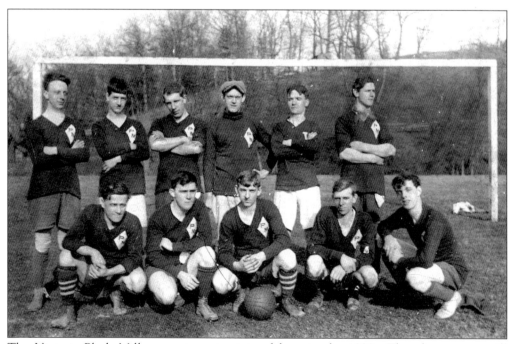

The Victoria Plush Mill soccer team is pictured here in the 1920s. The players were mill workers. They competed with teams from other mills. (Springfield Historical Society.)

The Springfield Boys Club was organized in 1931. On the 1934 team, from left to right, are the following: (first row) Paul Malseed; (second row) Murphy Pritchard, Phil Mowrer, Sam Warburton, Joe Carroll, and Bill Hooper; (third row) Chic Crothers, Jim Nulty, coach Pop Pritchard, Charlie Carroll, Hugh Bathgate, and Joe Baker. (Eileen Mowrer.)

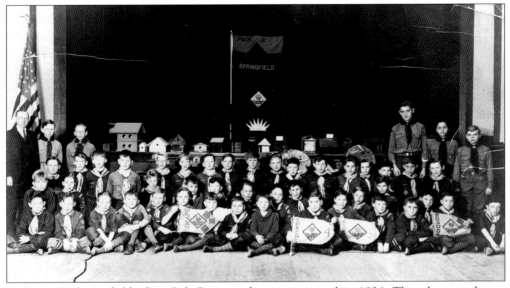

Pack No. 2, Springfield's first Cub Scout pack, was organized in 1936. This photograph was taken in the auditorium of Central School in 1939. Identified are the six people in the third row, from left to right, scoutmaster Harry G. Hough Sr. and Scouts Norman Saunders, Roy Hancock, Fred Wilcoxson, Al Godfrey, Robert Saunders, and Harry Hough Jr. The Scouts' birdhouses projects are displayed in the background. (Carl Hough.)

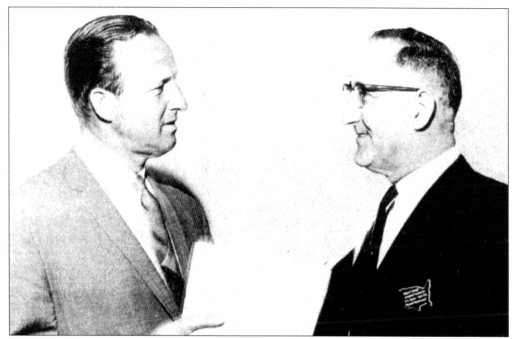

William F. Crowell (right) is congratulated by baseball star Stan Musial for being a finalist in America's contest of 12 top physical fitness leaders in April 1966. Crowell was one of the founders of the Springfield Athletic Association in the early 1950s and organized the baseball school. He also founded the Springfield chapter of the American Association of Retired Persons. Crowell Park on North Avenue is named after him. (*Springfield Press.*)

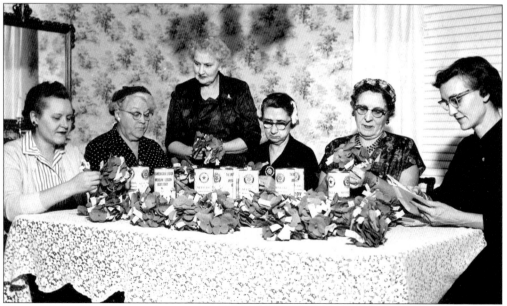

Women from the American Legion Post 227 Auxiliary assemble poppies for a program to help benefit disabled veterans. Poppy Day began after World War I and continues to this day. From left to right are Doris Foy, Edith Narbey, Mabel Menelly, Elizabeth McGarvey, May Whitley, and Lucille Basquill. The auxiliary was organized in 1925. (Springfield Historical Society.)

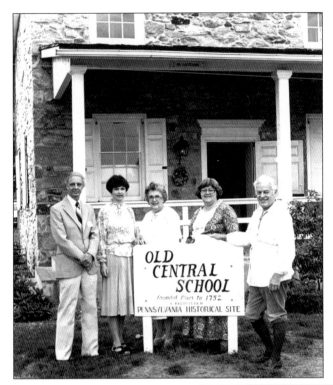

Pictured in front of Old Central School in 1979 are officers of the Springfield Historical Society. From left to right are Bill Henderson, vice-president; Kathy DeFina, director; Louise Wentz, president; Pat Gaines, director; and Bill Naylor, former president. Naylor spearheaded the restoration of Old Central School, which was built in 1852. (Springfield Historical Society.)

The Garden Club of Springfield was founded in 1931 with the objective of spreading a knowledge and love of gardening. Members aid in the protection of native trees, as well as encourage good civic planting in Springfield. Pictured are club members Pat Gaines and Betty Naylor and husband, Bill Naylor. They are attending the annual Hanging of the Greens, which is followed by a Christmas Tea at a historical home in Springfield. (Betty Naylor.)

Four

BALTIMORE PIKE
THROUGH THE YEARS

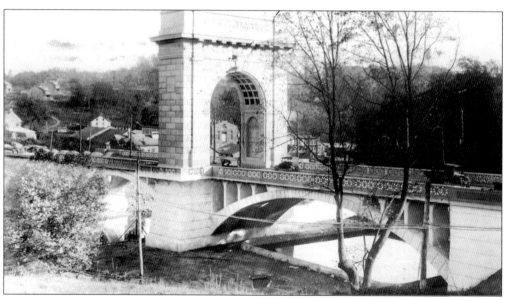

The Delaware County Memorial Bridge, located on Baltimore Pike over Crum Creek, was dedicated on June 16, 1926, as a memorial for all servicemen who died in World War I. A parade formed at the Media Courthouse and proceeded down Baltimore Pike to the bridge for the dedication, honoring the 282 servicemen, whose names were inscribed on bronze tablets attached to the bridge. In 1808, Baltimore Pike was a privately owned toll road and was known as the Philadelphia, Brandywine, and New London Turnpike. It was heavily used during the horse-and-buggy era and was paved with sturdy oak and hardwood planks. It was later renamed the Delaware County Turnpike. (Media Historical Society.)

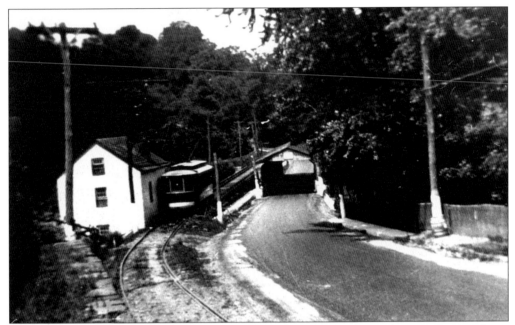

The Angora-to-Media "Toonerville Trolley" was started in 1894. This 1915 view shows the trolley crossing Crum Creek next to the covered bridge. In the early 1900s, the trolleys had a fare of 5¢ for a 20-mile ride. They were housed in a carbarn in Clifton. (Springfield Historical Society.)

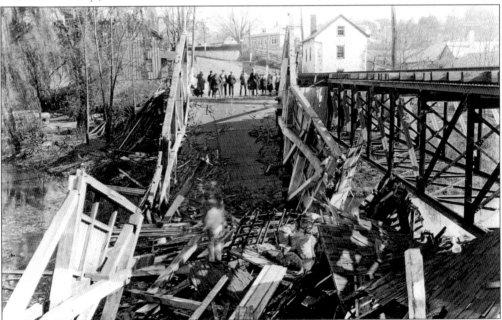

The covered bridge over Crum Creek collapsed in 1921. A truck loaded with potatoes was too heavy for the bridge, causing its collapse into the creek. The neighboring trolley track, however, was unscathed by the collapse, and people were still able to get back and forth across the creek via the trolley bridge. The wooden replacement was not a covered bridge. (Springfield Historical Society.)

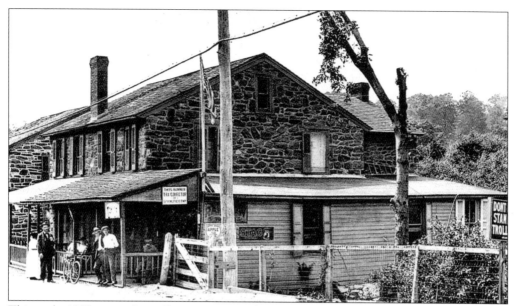

This early-1900s view shows Bonner's General Store, which was located on the north side of Baltimore Pike across from Victoria Plush Mills. Known as "Squire" Bonner, the store proprietor was also tax collector and magistrate. Next to Bonner's store were four mill houses. One of the mill house residents rented canoes and rowboats for trips up Crum Creek as far as the paper mills. (Keith Lockhart.)

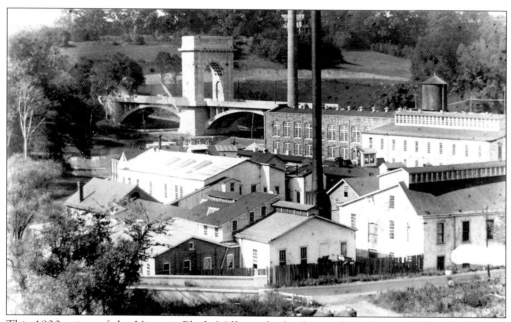

This 1920s view of the Victoria Plush Mill overlooks the small bridge on Wallingford Road, which leads to Nether Providence. The Turner brothers came from the British Isles and named this mill after Queen Victoria. The smokestack bears the name "Victoria," and this landmark can be seen from Baltimore Pike. In 1808, Baltimore Pike was a privately owned toll road known as the Philadelphia, Brandywine, and New London Turnpike. (Springfield Historical Society.)

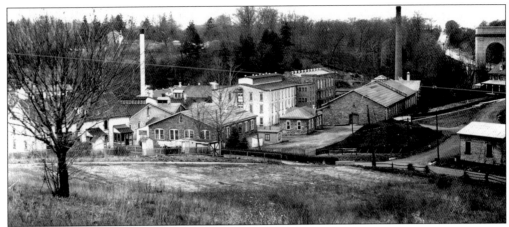

Victoria Plush Mills, shown here c. 1930, was located east of Crum Creek on Baltimore Pike. In 1898, John and Arthur Turner started to manufacture plush, which was similar to velvet but had a deeper pile. Plush was used in draperies, furniture, theater curtains and seats, and upholstery for automobiles. A powerful steam whistle, which sounded at 6:00 a.m., 12:00 noon, and 6:00 p.m., informed employees of the workday hours. (Springfield Historical Society.)

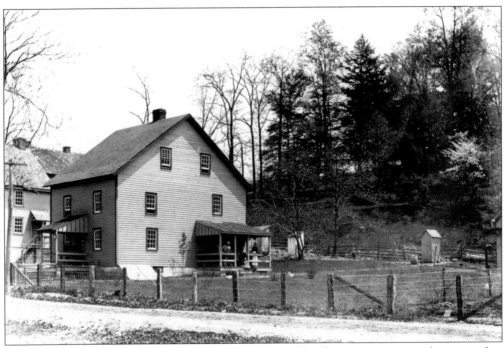

In 1897, Nellie Woodhead converted the front room of her house into a general store, with a potbelly stove that heated both the store and home. She operated her store for more than 50 years and was in her nineties when it closed. The general store was located in the Victoria Plush Mills Village on Wallingford Road. Notice the outhouses in the back, as indoor plumbing had not made it into any of the mill houses by the time of this 1910 photograph. This home is still occupied today. (Sarah Bewley Rann.)

This photograph would make an good ice-cream advertisement. Sarah Bewley and Betty Woodhead enjoy their ice-cream cones outside their grandmother's general store in 1930. The general store was located on Wallingford Road in the Plush Mills Village, just east of Crum Creek. (Sarah Bewley Rann.)

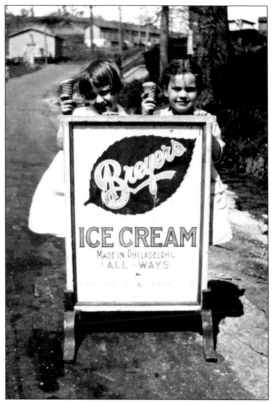

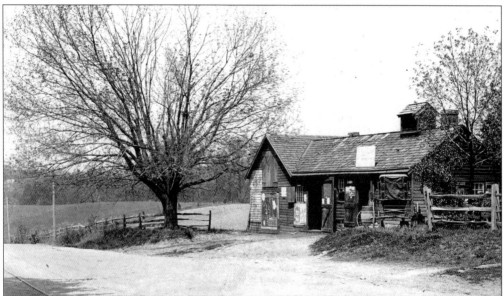

This 1908 photograph shows John Taylor's blacksmith shop on Baltimore Pike. This portion of Baltimore Pike was called Blacksmith Hill. Taylor started his business in 1856. In 1908, John Graham, a wealthy carpet manufacturer, purchased a large tract of land for his home and the blacksmith shop was razed. The site is now the parking lot on the west side of Springfield Mall. (Delaware County Historical Society.)

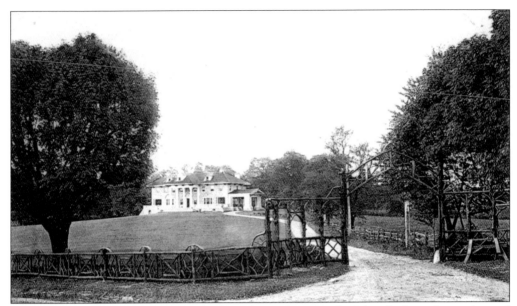

Maerex-on-the-Hill was a mansion built in the early 1900s for John Graham. It was located high on the hill, facing Baltimore Pike west of Sproul Road and the Gibbons Farm. In 1933, Gertrude Stewart bought the property and operated it as the Stewart School for Retarded Children until her death in 1970. Sold in 1972, the property is now the west side of Springfield Mall. (Keith Lockhart.)

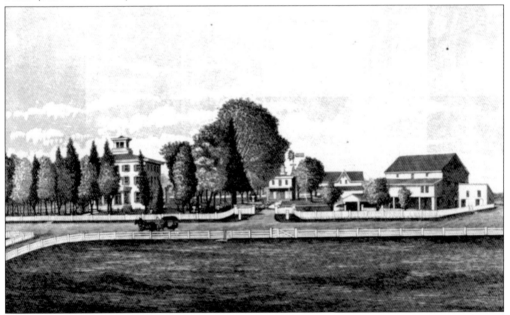

This sketch shows the Gibbons homestead and farm, located at Baltimore Pike and Sproul Road (now the Springfield Mall). Joseph Gibbons built the 16-room mansion in 1832. The three-story brick home, tenant houses, and large barn faced Sproul Road. Two additional tenant houses, a carriage house, and many other buildings stood elsewhere on the Gibbons property. In 1939, the mansion became a retirement home for dependent Protestant woman over 40. (Henry G. Ashmead, 1884.)

Joseph Gibbons Jr. was born in 1799 in Springfield and became a prosperous Chester banker, gentleman farmer, and organizer of the Delaware County Insurance Company. A member of the Society of Friends, he married Hannah Powell of Springfield. The couple had eight children—four boys and four girls—and forbade them to marry, under the threat of being disinherited. Gibbons died in 1880. (Henry G. Ashmead, 1884.)

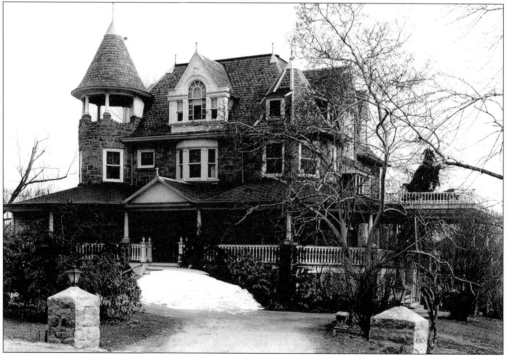

Elnwood Nursing Home, pictured in 1954 at Baltimore Pike and Lincoln Avenue, was built in 1895 by John McGonaghy for his residence at a cost of $15,000. The stone came from the Woodland Avenue quarry. The carriage house was a workshop for local balloonists in the 1950s. The balloon used in Mike Todd's film *Around the World in Eighty Days* was manufactured here. Today, this is the site of Springfield Square South Shopping Center. (Media Historical Society.)

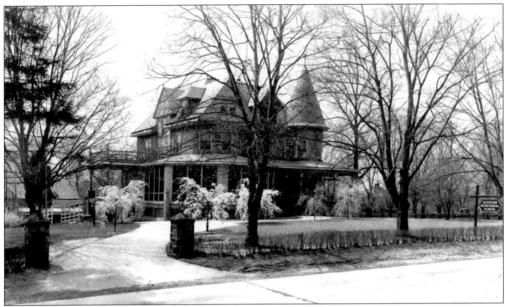

Pictured in 1940, the Keystone School of Business was built as a private residence at 965 Baltimore Pike in 1895. In 1939, Grover and Ethel Greene bought the property and operated a private business there until 1988. The Chubb Institute purchased the place and leased it for 10 years. The building was demolished in 1998 to make way for a retail center. (Doris Greene Smith.)

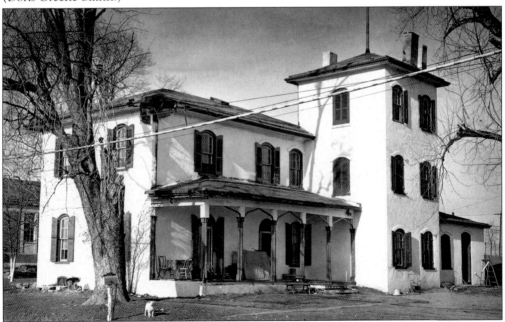

Pennsdale, the Thomson farmhouse, was built in the 1700s on the northeast corner of Baltimore Pike and Thomson Avenue. The barn and springhouse were on the south side of Baltimore Pike, and the farm property extended all the way to the railroad in Morton and back to the area where Sabold School is today. Pictured in 1954, the Thomson house was razed in the same year and later replaced by Embers Restaurant. (Delaware County Historical Society.)

J. Edgar Thomson, a railroad pioneer, became the first chief engineer for Pennsylvania Railroad and, later, the railroad's third president. He designed the main line from Harrisburg to Pittsburgh and also the famous Horseshoe Curve, west of Altoona. (Ashmead 1884.)

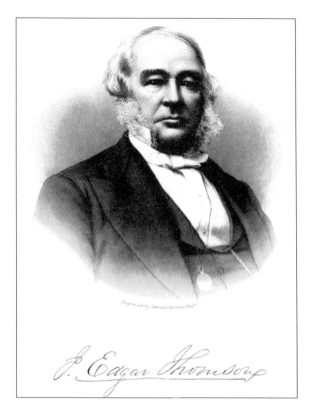

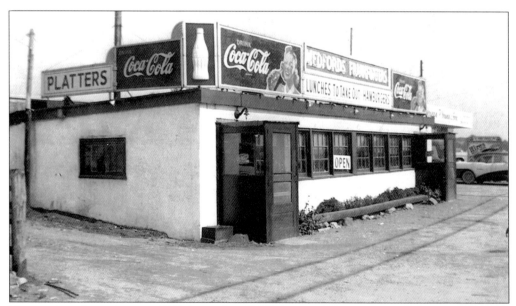

Newsom's is shown here in 1953, located at 880 Baltimore Pike just east of Thomson Avenue. The Dollos family bought the property in 1953 and, in 1955, built the new R-Way Diner—a classic 1950s shiny, stainless steel diner. An automobile dealership now occupies this site. (Springfield Historical Society.)

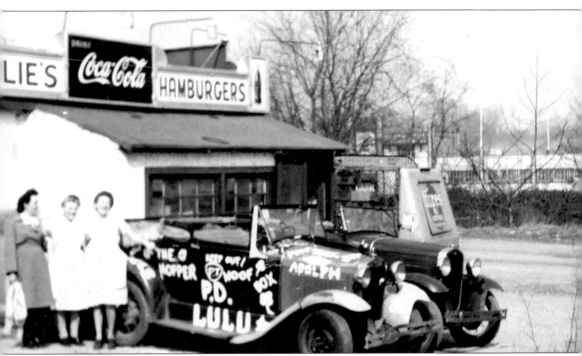

This 1947 photograph shows Paul Shea's 1930 Ford Cabriolet covered with graffiti. Shea's friends Franklin Pancoast and Bob "Soup" Campbell decorated the car with house paint, which remained for some time. Across Woodland Avenue is the Springfield Pool. A Hires root beer delivery truck is parked by Charlie's Hamburgers. From left to right are Charlie Convery's sister-in-law, mother, and wife, Bea Convery. (Joy Conard Settles.)

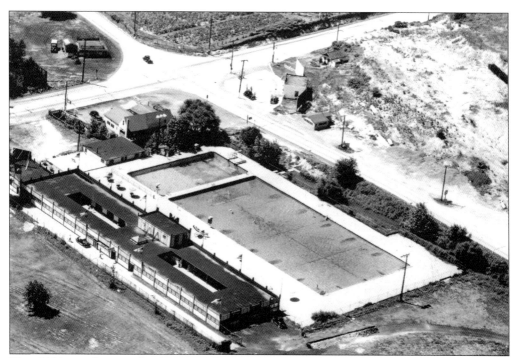

This 1939 aerial view of Baltimore Pike and Woodland Avenue shows the Springfield Pool, later the Palm Beach Club, and Harry Liberato's Burgers, later Walt's. On the northwest corner is a gas station, Charlie's Hamburgers, and Grunwell's Sleepy Hollow produce stand facing Baltimore Pike. The white area behind the building is Evans Quarry. Newsom's Hamburgers is on the southeast corner and Newsom's cornfield is across the street, later the site of Strawbridge's. (Springfield Historical Society.)

Sitting on the sand at Springfield Pool in 1929 are Lou Rose (front center) and his friends. In later years, Rose served as a commissioner of Springfield Township. Built in 1928, the 100-by-250-foot pool cost $100,000. Steve and Sam Photos were the owners when the pool closed in 1960. "Farmer" Dick Barone bought the property, and today, it is the site of Rothrock Chevrolet. (Dotty Lou Rose.)

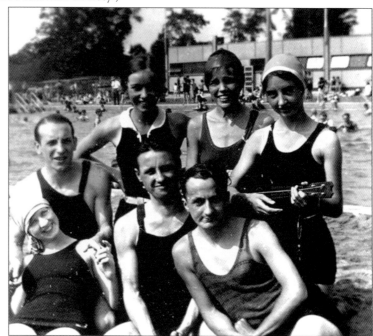

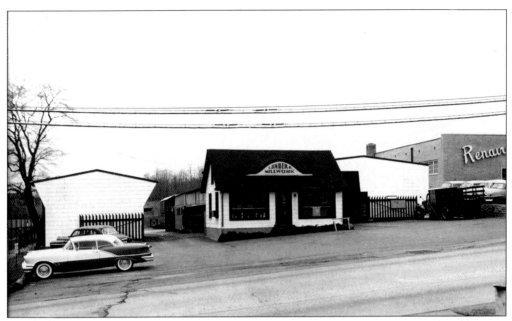

Springfield Supply Company Lumber & Millwork was started by William Sprengel and his son, William Sprengel Jr., in 1946. Sprengel's wife, Mary, worked in the office of this family business, located at 778 Baltimore Pike. The lumberyard in the rear was next to the Springfield Pool. This 1958 photograph shows part of Renaire Frozen Food Center (right). Chrysler bought the property in 1963. (William Sprengel.)

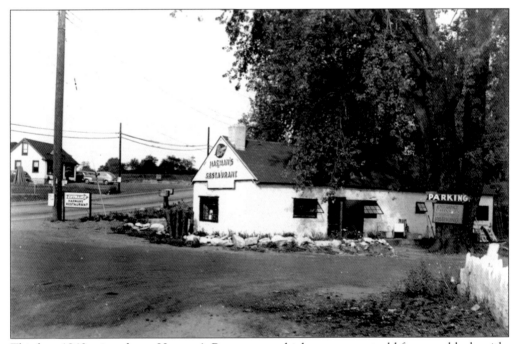

This late-1940s view shows Harman's Restaurant, which was once an old forge, or blacksmith, shop. It was located on Baltimore Pike at the stream across from the Springfield Pool. Sprengel's lumberyard can be seen across the street. (Don Burke.)

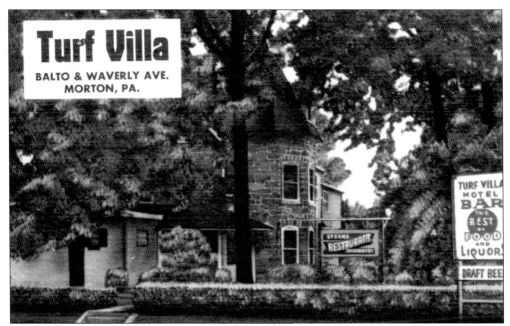

Originally the Greystone Inn, the Turf Villa Hotel was located at Baltimore Pike and Waverly Avenue in Morton, next to Playtown Park. This postcard is from the 1950s. In 1989, the building—then known as the Heritage House—was razed to make way for a row of stores. (Keith Lockhart.)

Shown here is a collection of memorabilia from Playtown Park, popular between 1950 and the 1960s. The park had a Ferris wheel, a merry-go-round, boat rides, small cars, a miniature golf course, and many other amusements. Located on Baltimore Pike in Morton, the park was replaced with Clover Department Store and now is the site of Kohl's. (Springfield Historical Society.)

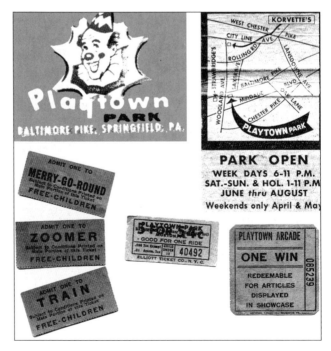

Luciani's Restaurant, at 720 Baltimore Pike, opened in 1956 as an ice-cream parlor that also served sandwiches. After a few years in business, the restaurant added dinners, including "broasted chicken" and homemade Italian cuisine. The business was sold in 1980 and is currently a Bennigan's Restaurant. (Joe Luciani.)

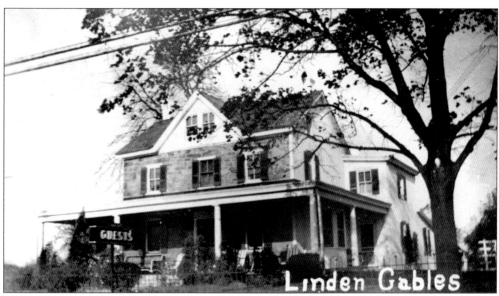

This early-1940s view shows Linden Gables guesthouse, on the northeast corner of Baltimore Pike and Leamy Avenue. The Philadelphia Trailer Company also operated from this location, which is today the home of Ferraro Cadillac. (Keith Lockhart.)

This 1900 view of Baltimore Pike was taken from a sleigh (notice the back of the horse). It looks eastward between Leamy and Saxer Avenues, showing Alwine's Nursery (left) and the Leamy Farm. The area is currently the site of Best Buy and the Alpine Motor Lodge. (Springfield Historical Society.)

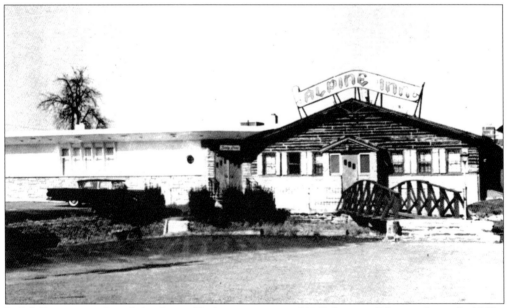

Ralph Puppio purchased the Swiss Chalet property, at 642 Baltimore Pike, in the early 1950s. He renamed it the Alpine Inn, and it became a popular banquet facility. As the business grew, he purchased the adjoining DiLuzio's Nursery and built a motel. The stream running under the bridge to the entrance provided a great place to ice-skate in the winter. (Lou Saddic.)

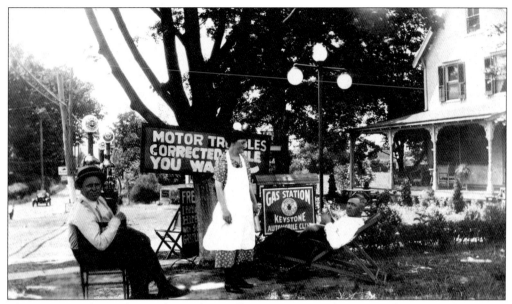

This appears to be a relaxing day at the Walls Gas Station and Garage. The sign reads, "Motor troubles corrected while you wait." From left to right are Millard C. Walls and Clara and Frank Edwards. In this 1924 view, Baltimore Pike is a dirt road and the trolley run down the south side. (Rhoden Walls.)

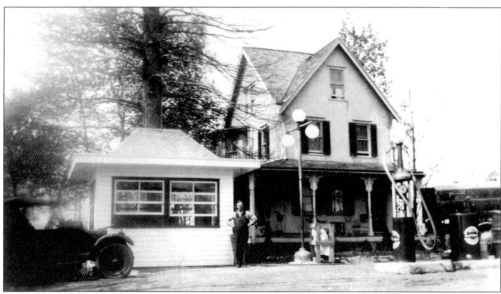

This 1926 photograph shows the Walls home, known earlier as the Leamy Farm. Millard C. Walls sold candy, ice cream, hot dogs, and cigarettes in the store that he built. In the late 1920s and early 1930s, he built four motels on the east side of his property. Tourists came from Philadelphia to spend the weekend in the country. Many years later, the Alpine Inn was developed on the property to the left of this location. (Rhoden Walls.)

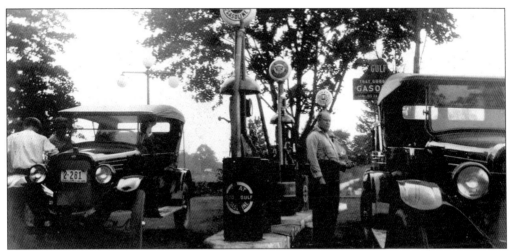

Millard C. Walls stands next to the gas pumps at Walls Gas Station in 1926. He was in business at this location, on Baltimore Pike west of Saxer Avenue, from 1924 to 1935. The farm buildings at the rear were used as a boxers' training camp, owned by Max Boo Hoff. The boxing ring was outdoors. It closed in 1929. (Rhoden Walls.)

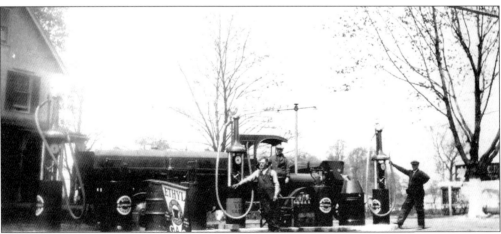

This gasoline truck makes a delivery at Walls Gas Station. Notice the open cab on the truck and the old gas pumps. LeBaron's real estate office was located to the right of the gas station near Saxer Avenue. (Rhoden Walls.)

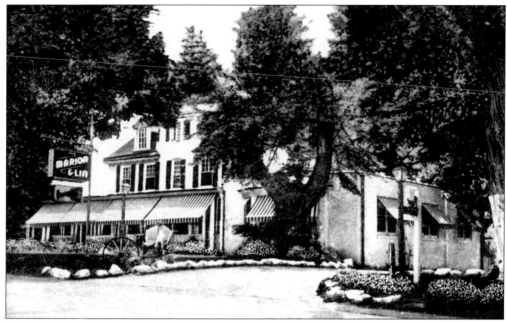

This 1940s view shows the Marion & Lin Inn, owned by Marion and Linwood Merz. The three-story building was constructed in 1834. It stood on a 17-acre lot, complete with stables for 40 horses. Today, it is the Springfield Inn, located at 417 Baltimore Pike. The original structure still remains within the current building. (Don Burke.)

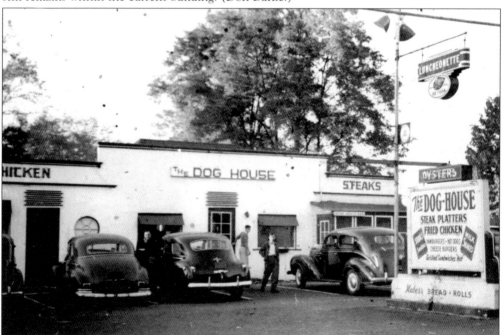

The Dog House, on Baltimore Pike and Norwinden Drive, was a popular gathering spot for young people from Springfield and surrounding towns from 1945 until 1974. Owners Bill and Roy Wunder hosted many high school football banquets at the Dog House. Located here today is a CVS, and prior to that, Sparn's Seafood. (Chuck Wunder.)

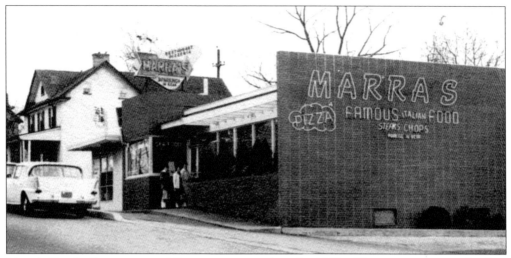

Marra's Family Restaurant and Pizzeria is pictured in the 1960s. The restaurant specialized in Italian food and pizza. Located at 313 Baltimore Pike, Marra's advertised with many neon signs. The restaurant is now a car dealership. (Springfield Historical Society.)

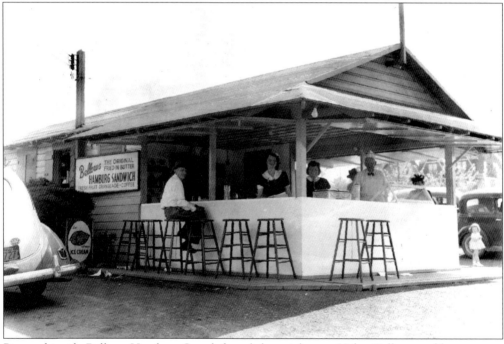

Pictured inside Bellows Hamburg Stand, from left to right, are Helen Bellows and her parents, Alice and Ed Bellows. Alice Bellows made a delicious chili relish, and Ed Bellows had a secret recipe for fresh fruit orangeade. The orangeade cost 10¢ a glass, and sodas cost 5¢. The hamburgers, or hamburg sandwiches as they were known then, were fried in butter. At night, the stools were put inside and the wooden sides closed to secure the building. In those days, that was all the security that was needed. (Cliff Bellows.)

This 1938 photograph shows the men who worked at Bellows Hamburg Stand. From left to right are Edgar Masson, Cliff Bellows, Nathan Stewart, and Bob Smith. A family-operated business, the stand was located on the southwest corner of Baltimore Pike and Homestead Avenue from 1930 to 1945. The family's first stand operated from 1928 to 1929 on Newsom's property at the southeast corner of Baltimore Pike and Woodland Avenue. (Cliff Bellows.)

The Charles Shute home, at 2 Baltimore Pike, was built in 1912. Stone for the 16-room house came from Evans Quarry, located at Baltimore Pike and Woodland Avenue. Charles Wright, Shute's grandson, operated Wright's Farm Market at this site for many years. Later, Spano Real Estate rented the house for its office. In the mid-1960s, Shell Oil Company leased the property and the house was razed. Walgreen's now owns the property. (Charlie Wright.)

Five

EARNING A LIVING

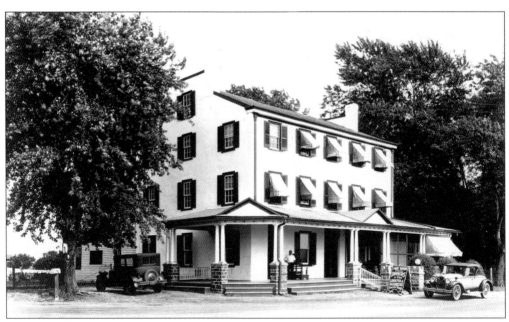

The Lamb Tavern was originally known as the Three Tuns Tavern. Eamor Eachus built it in 1808, and in 1835, the name was changed to the Lamb Tavern. The Lamb hosted sheep auctions, hay and onion set sales, and was a military meeting place, in addition to being a local watering hole. The original tavern was located on the land where Springfield Mall now stands and was operated by Joseph Gibbons from 1766 to 1835. (Delaware County Historical Society.)

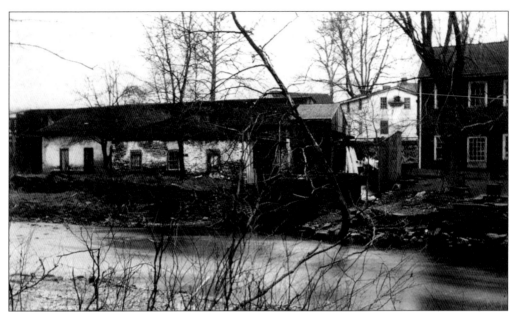

In 1825, William Beatty became the first man in the United States to manufacture edge tools from cast steel. After his death in 1842, his sons William and John Beatty continued the business. During the flood of 1843, all of the buildings except one were destroyed. The sons rebuilt the mill, and by 1860, had 30 employees and turned out 200 tools a day. The one building that survived the flood is used by water company today. (Keith Lockhart.)

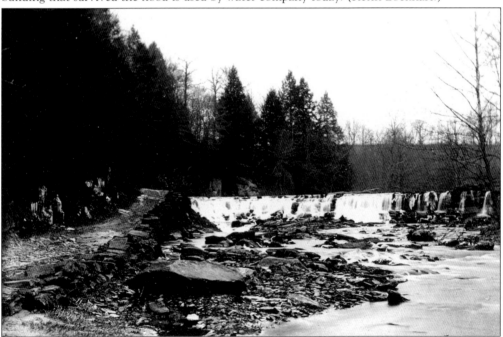

Pictured in 1890 are the Crum Creek Falls at Beatty Road. William Beatty purchased the area bordering on Crum Creek in 1825 and constructed a forge and blade mill for manufacturing edge tools. This property was part of the original land grant from William Penn to Bartholomew Coppock. (Keith Lockhart.)

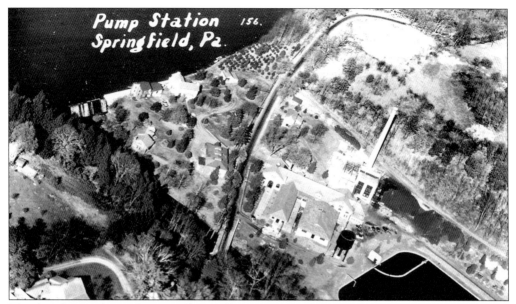

This aerial view shows the 90-million-gallon Crum Creek Reservoir behind the 1918 masonry dam in the upper left corner. Beatty Road can be seen cutting through the center of the photograph, with the original No. 1 pump house at the center. A greatly expanded plant fronts the 1899 stone building, as well as a new electrical generating plant with a large coal supply visible to the right of the building. (James Garoh Jr.)

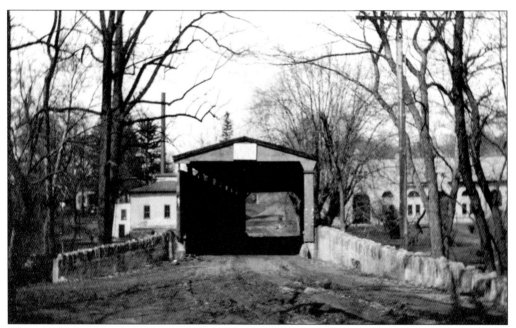

This 1916 photograph looks north through the covered bridge over Crum Creek at Beatty's Hollow. The original Crum Creek Pumping Station is to the left of the bridge, with the smokestack to the auxiliary steam-powered plant visible behind it. The stone building to the right of the bridge is the Springfield Consolidated Water Company's pumping and filtration building, dating from 1899. (Delaware County Historical Society.)

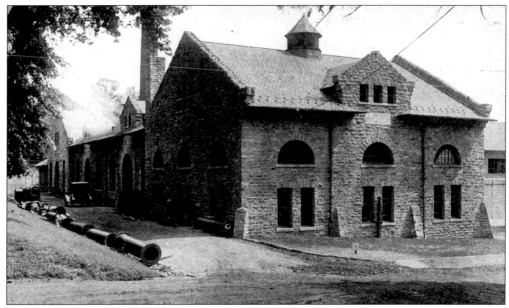

This early-1920s photograph shows the Springfield Water Company's pumping and filtration building. Located at Crum Creek, this elegant stone building replaced the original Crum Creek Pumping Station. The stone below the clerestory window is inscribed with the date 1899. Today, the three million gallons of water per day pumped through the plant help satisfy the growing needs of the Delaware County area. (Keith Lockhart.)

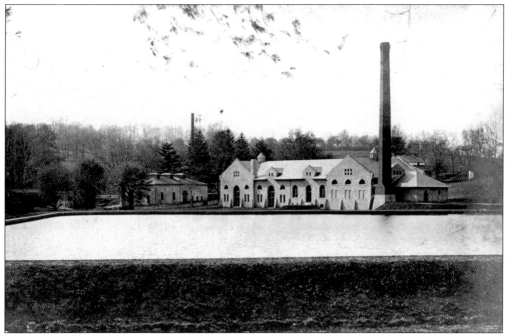

This c. 1900 view shows the original Crum Creek Pumping Station No. 1 (left) and the grand 1899 pumping and filtration building, standing guard over the basin. The plant's large smokestack was connected to the coal-burning boilers used in pumping water throughout the system. (Delaware County Historical Society.)

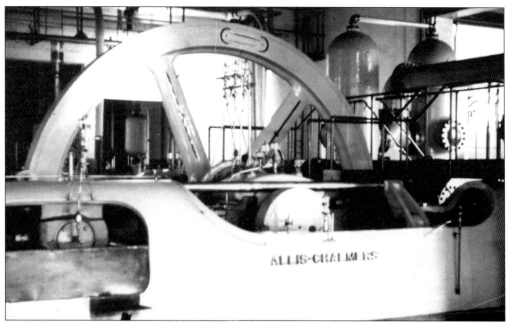

The first steam-driven turbine and centrifugal pump were installed at Springfield Water Company's Crum Creek Pumping Station in 1926. In 1892, Pumping Station No. 1 was operated by waterpower, with an auxiliary steam plant. Located on Beatty Road, this white stucco building is the only Beatty Axe Works structure to have survived the flood of 1843. The high-water mark can still be seen on the building. (Media Historic Archives.)

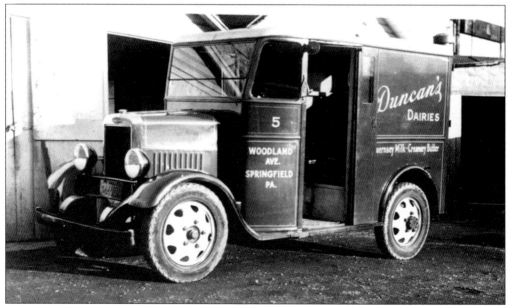

Duncan's Dairies was a family business started on Woodland Avenue by George Duncan in 1921. The milk truck shown in this 1937 photograph was a familiar part of the life in Springfield, making rounds delivering milk to people's doorsteps. The Duncans opened an ice-cream parlor in 1940 in the same building that operates today as the Dairy Cottage restaurant. Duncan's Dairies merged with Miller-Flounders in 1941. (Bob Duncan.)

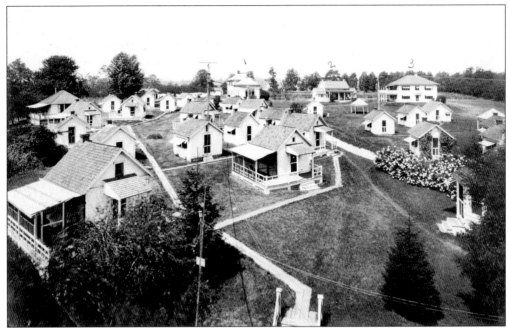

Dermady Sanatorium operated as a tuberculosis treatment facility on a 64-acre plot along Woodland Avenue, now the site for E. T. Richardson Middle School. Margaret O'Hara, a nurse, bought the property in 1898 and operated this private sanatorium until her death in 1924. Among the buildings shown are the dining room (1), the recreation cottage and library (2), and the flower cottage (3). (Springfield Historical Society.)

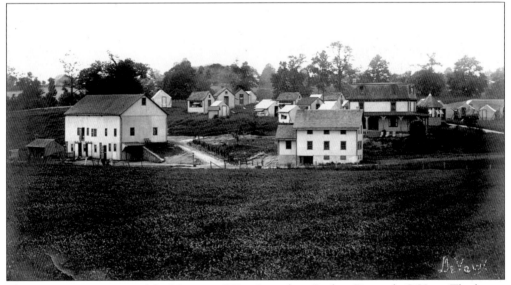

The sanatorium was named for Margaret OHara's mother, Bridget Dermady O'Hara. The house with the mansard roof (tallest one on the right) was the original farmhouse. It served as Margaret O'Hara's office and living quarters and as housing for the nurses. The farm at Dermady Sanatorium grew vegetables and raised cows, chickens, and other animals. George Addis worked for Margaret O'Hara for many years as the farmer, gardener, and carpenter. (Springfield Historical Society.)

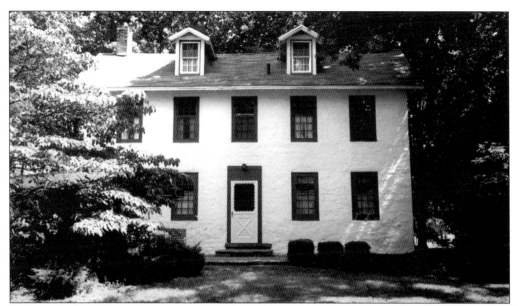

Built in the late 1700s, the Samuel Hall House is located at 962 Westfield Road, in the Stoney Creek area. In 1910, the Pratt Poultry Experiment Farm occupied this 100-acre farm, which produced "better bred" poultry and won awards for its high egg production. Chicks and fertile eggs could be purchased at the farm or through Pratt's mail-order business. Stoney Creek is a residential community today. (Keith Lockhart.)

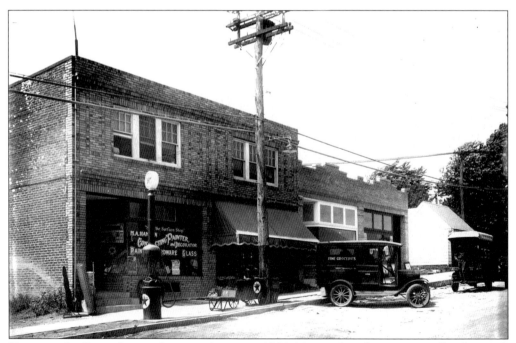

Shown is the Saxer Avenue business district in 1924. Notice that the street is still a dirt road. Hansen's Hardware is located at 152 Saxer Avenue, and Crass' Market is next door. The small frame building (right) is a real estate office, located next to the trolley tracks. Gilday's ice truck is traveling up the hill. (Keith Lockhart.)

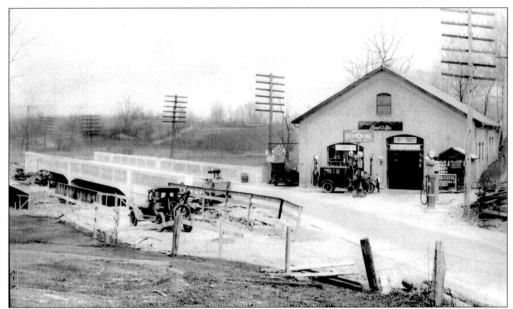

Ted Gilday's Springfield Auto Service stands at State and North Rolling Roads in the 1920s. This building was originally the Darby Creek Water Pumping Station and is now Prince Automotive. Ted Gilday sold candy in a small shed (right) that he erected in front of the store. Notice the new concrete bridge and the remains of the old covered bridge (left). (Doris Gilday Hohn.)

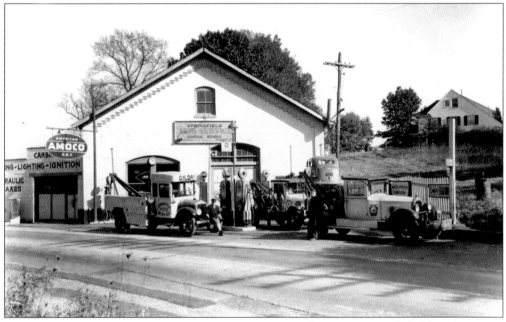

Outside with his fleet of tow trucks, Ted Gilday sits on the bumper of a truck (left) in the 1930s. His house is seen on the hill, at 423 North Rolling Road. In 1951, State Road was widened and substantially elevated to accommodate the ever-increasing traffic at this major crossroads. As a result, the house is now level with State Road and the auto service garage is down in a hollow. (Doris Gilday Hohn.)

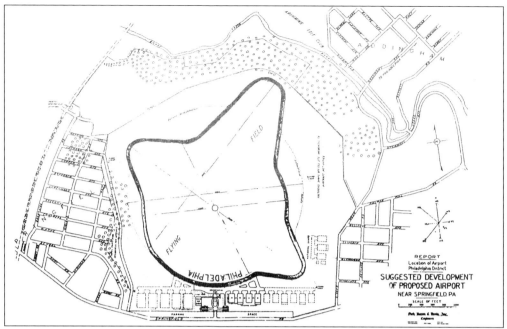

In 1928, a municipal airport was proposed for the plateau along which Scenic Hills and Norwinden Roads now run. The tract of ground was about 400 acres. The property cost was estimated at $1 million and the development cost at $707,000. However, no planes ever got off the ground, as this plan was scraped. (Springfield Historical Society.)

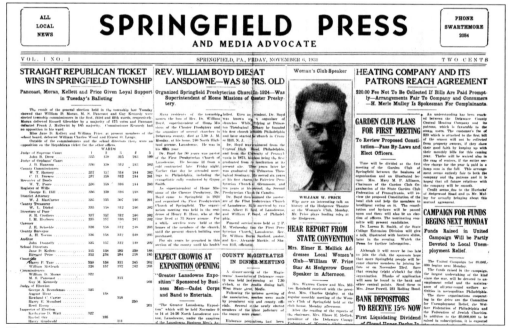

Shown here is the first issue of the *Springfield Press*, dated Friday November 6, 1931. James T. Crowe served as editor and business manager, and Reese Crowe served as secretary. The price of the paper was only 2¢ a copy, and the phone number was Swarthmore 2084. The *Springfield Press* is still published every Wednesday. It now costs 50¢ cents a copy. (*Springfield Press*.)

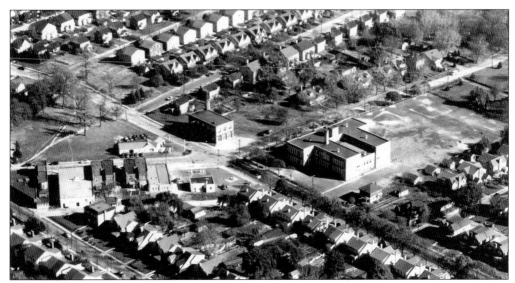

This 1940s view shows the first block of the Saxer Avenue Business District. Central School is on the southwest corner of Saxer Avenue and Powell Road, and the firehouse is across the street. There is a gasoline station on each of the opposite corners. Notice the paths through the field, which is now the township parking lot. In the foreground are homes on Ballymore and Powell Roads. (Don Burke.)

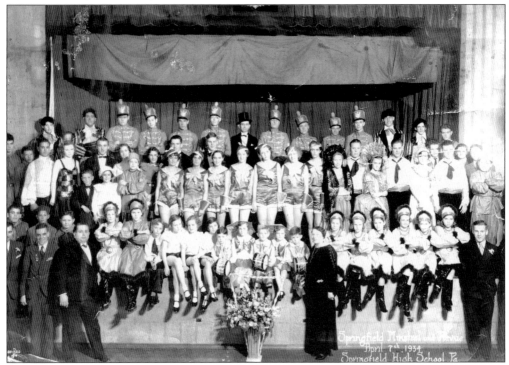

In 1934, the annual Minstrel Show at Springfield High School featured a cast of more than 100. Those responsible for the event, held on April 6 and 7, included "Jud" Staley, director; Erna C. Staley, choreographer; Harold Owens, business manager; John Pfleiger, stage manager; and Paul Pfleiger, piano player. (Eileen Mowrer.)

The central heating plant of the Springfield Steam Company was located at Harwicke and Alford Roads. It was a privately owned company that began operations in 1927. Through underground pipes, the plant supplied modern and clean steam heat to homes on Hart Lane and Harwicke, North Rolling, South Rolling, and South Hillcrest Roads. Each house had its own meter. The company went bankrupt in February 1936. (Harry Bornman.)

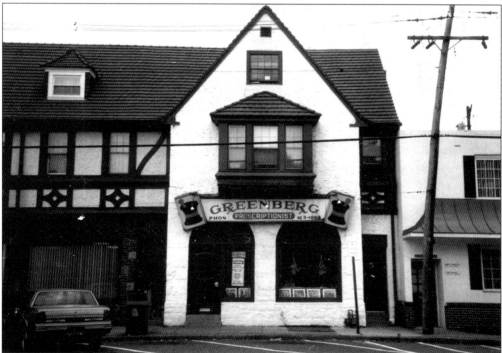

Dr. Harry E. Greenberg came to Springfield in 1928 and opened this drugstore at 5 Brookside Road. Besides being one of the first drugstores in Springfield, Greenberg's became a local hangout for teenagers. James Okino, a pharmacist, came to work for Greenberg in 1950 and later bought the business from him. (James Okino.)

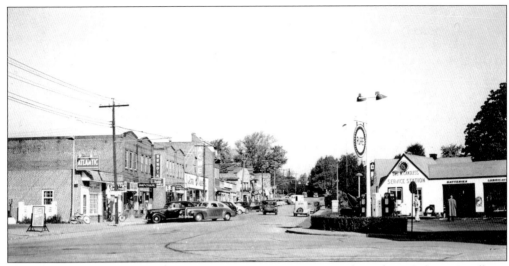

Shown is the Saxer Avenue Business District in the 1940s. On the right is Bob McCandless's Service Station. On the left are an Atlantic Gas Station, Boyd Realty, Dominick's Barber Shop, Sam's Tailor Shop, Sol Levin Bendix Appliances, Ruggierio Family Shoe Service, Averdisian Dry Cleaners, Acme, Cuthill and Newberg's Notary, and the five-and-dime store. The upper block had two drugstores named Rigg's and Whitley's, the post office, Peoples Hardware, and Harry's Tailor Shop. (Angie Ruggierio Carrao.)

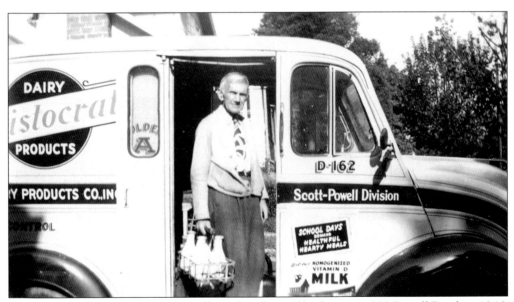

William Campbell pauses with his milk truck in front of his house, at 300 Powell Road, in 1946. Each night, customers set out empty milk bottles with a note to Campbell indicating how much milk he should leave at their steps the next morning. (Bob "Soup" Campbell.)

This 1950s photograph shows Henry Grebb's produce stand, on the northwest side of State Road. Henry Grebb sold fresh eggs from Lancaster County, frozen foods, honey, ice cream, and soda. Jerry Collins leased this property to Grebb from the mid-1940s to 1952, when State Road was first widened. (Bob Collins.)

Jerry and Clara Collins purchased this property at State and Sproul Roads in 1944. Both roads were still two-lane in this 1950 photograph. The twin house on the northwest corner of Sproul Road was the Collins home, and the gas station on the corner of State Road was operated by Jerry Collins. Collins Drive was named after grandfather Patrick Collins. (Bob Collins.)

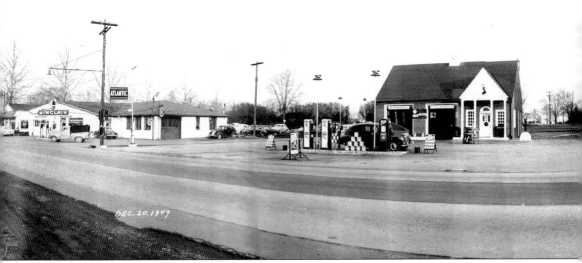

This panorama, taken in 1949, shows the Chester Road shopping area. From left to right are the Fusco & Alston Studebaker Dealership, Fusco's Sinclair Gas Station, Atlantic Gas Station,

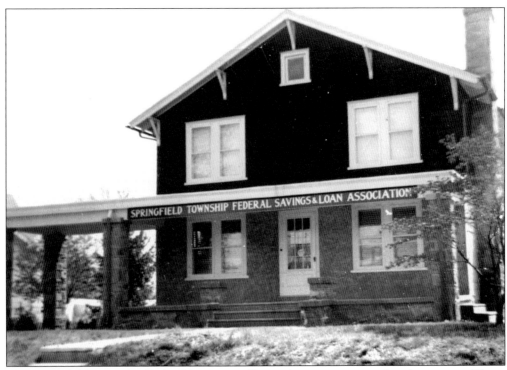

The Springfield Township Federal Savings and Loan Association opened at the corner of Saxer Avenue and Hart Lane on March 6, 1953. The officers were Henry LeBaron, Robert Race, Lloyd White, Earl Miller, and John Kennedy. The directors were William Allison, William Carter, Earl Duncan, Walter Helm, George Karge, Ross Osborn, and Ed Walsh. Today, the building is the site of Alliance Bank. (Springfield Historical Society.)

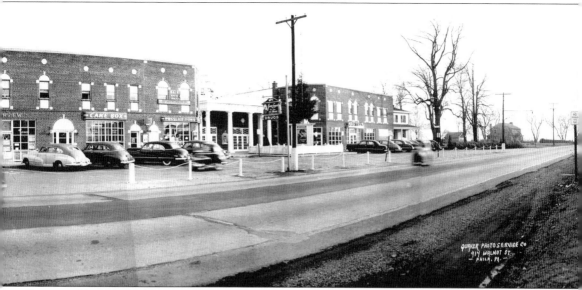

Fairview Cleaners, Cake Box Bakery, a drugstore, the College Theater, Martel's Grocery Store, and a private residence. (Springfield Historical Society.)

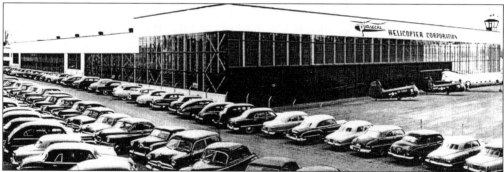

The Piasecki Helicopter Corporation dedicated its new plant on Woodland Avenue in May 1947. Frank Piasecki was a pioneer in the development of helicopters. On the right side are military helicopters and the control tower. In 1956, the corporation became Vertol (an acronym for vertical take off and landing) Aircraft Company. In 1960, it became the Vertol Division of the Boeing Company. Today, this building is the site of BJ's Warehouse. (Springfield Historical Society.)

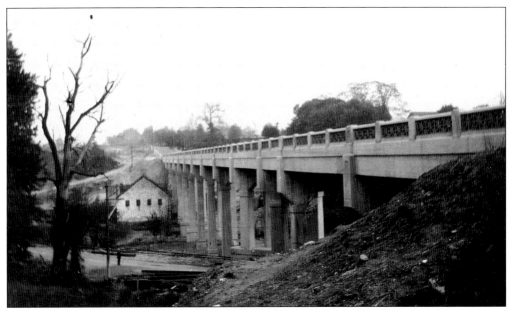

The Avondale Bridge on Chester Road (Route 320) over Crum Creek replaced the covered bridge that had previously spanned the creek. This 1923 view looks from Springfield toward Nether Providence. Thomas Leiper had granite quarries in this area, including one in Springfield that later became the Morrow Quarry. (Delaware County Historical Society.)

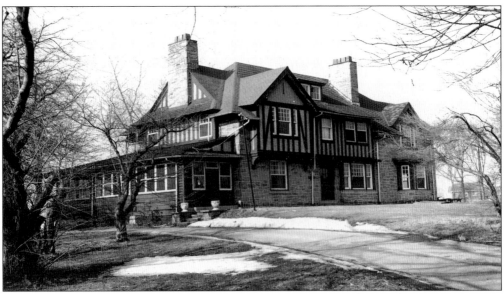

The Frank Tobey farmhouse was built in the late 1890s on the Taylor-Evans property. In the late 1940s, Thomas Sheridan purchased the property and built a public golf course, utilizing the Tobey farmhouse as the clubhouse. Springfield Township bought the property and used the Tobey house until the present-day country club facility was built. (Springfield Historical Society.)

Six

READIN', 'RITIN',
AND 'RITHMETIC

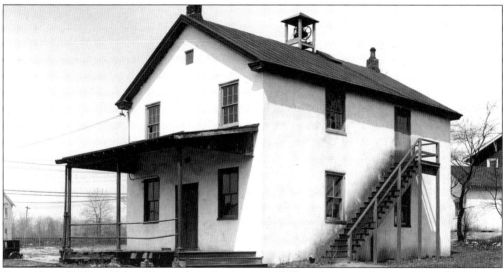

Central, or Yellow, Schoolhouse dates back to c. 1752 at this site. It was replaced by a new school in 1852, which is shown here. Originally, one teacher taught all grades on the first floor and the second floor was used for storage. In 1887, the students raised money to buy a school bell that cost $24.50. That bell remains atop the school today. In 1910, there were two teachers: Ella Nutt taught grades one through four on the first floor, and Miss Fudge taught grades five through eight on the second floor. The outhouses were located at the rear of the building. Today's parking lot was a large field with many oak trees. Drinking water was brought in with buckets from the spring outside. Central School was used continuously until 1921. The township took possession of it in 1947. The school was restored in the late 1970s and was placed on the Pennsylvania Inventory of Historic Places. (Springfield Historical Society)

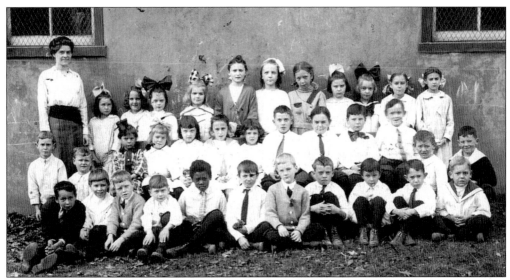

Teacher Ella Nutt (back left) and her students pose outside Old Central School in 1913. From left to right are the following pupils: (first row) unidentified, Joseph Lownes, Harry Evans, Herbert Fetters, unidentified, John Roberts, Joseph Evans, Edward Gormley, unidentified, Clifford Evans, and Louis Ottey; (second row) George Mayer, seven unidentified children, John Ottey, Earl Duncan, unidentified, Vernon Church, and Bill Pancoast; (third row) Dorothy Roberts, unidentified, Margaret Evans, Mary Hipple, three unidentified children, Margaret Fetters, Beatrice Churchman, Mildred Fetters, and Alice Thompson. (Jane Lownes Shea.)

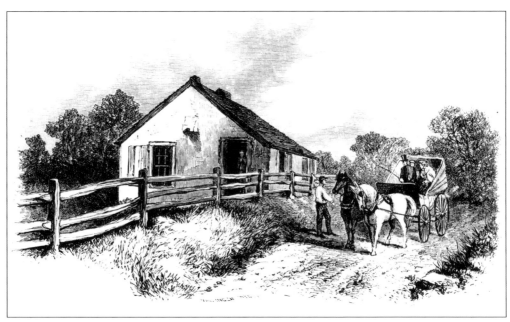

The Horne School was a joint venture between Springfield and Ridley School Districts. A one-room school was built c. 1793 on the west side of Swarthmore Avenue and Avondale Lane, just south of Yale Avenue. It was used until 1857, when Oakdale School was built on Baltimore Pike. It was torn down prior to 1900. (Keith Lockhart.)

In the early 1830s, William Beatty, Joseph Powell, and Seth Pancoast bought land from Thomas Maddock and built the Western School. By c. 1900, the school had become a community center. It was eventually was sold to Dr. Edward P. Cheyney, a professor at the University of Pennsylvania. On Christmas Eve 1926, vagrants set fire to the old school. The building survived and became a residence. Its 1856 date stone visible from Beatty Road. (Garden Club of Springfield.)

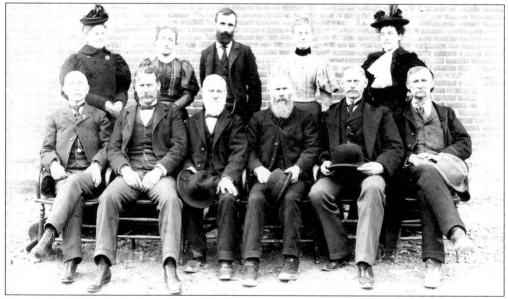

The Springfield school directors and teachers of 1897 are pictured here outside of Morton School, located at School and Baker Streets. From left to right are the following: (first row) directors Walter Simms, Frank Strickland, Joseph Bishop, William Parker, Samuel Evans, and D. Caldwell; (second row) teachers Miss Lang, Miss Dolphin, William Swank, Miss Smith, and Miss Howe. In 1898, Morton seceded from Springfield and the school was given to the borough of Morton. (Barbara Burke.)

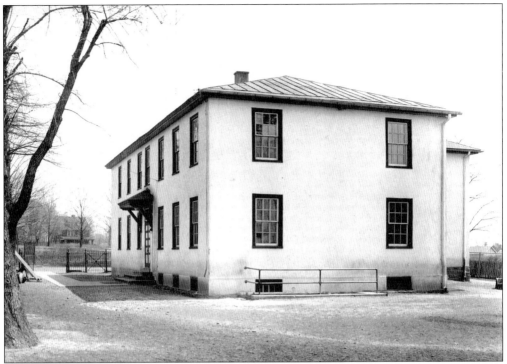

In 1857, the Oakdale School was built for grades one though eight on land purchased from Joseph Gibbons and James Ogden. The school stood on the south side of Baltimore Pike, just east of Chester Road, now Route 320. It closed at the end of the 1971–1972 school year and was demolished in 1974. A bank now occupies the site. (Springfield Historical Society.)

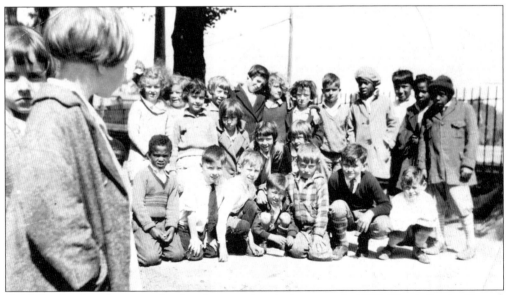

Oakdale school students pose for the photographer during recess in 1930. (Sarah Bewley Rann.)

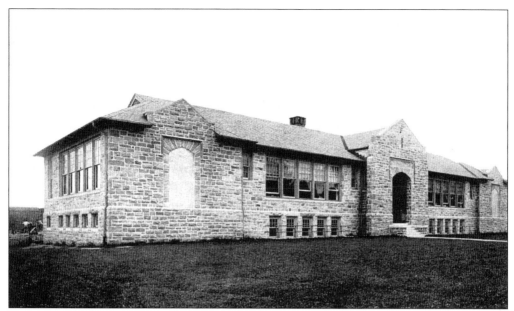

Central School, at the corner of Saxer Avenue and Powell Road, was built in 1921 as a single-story building with four classrooms. This 1924 photograph shows the two wings that were added: a cafeteria wing and a classroom wing, with an outdoor courtyard between them. (Keith Lockhart.)

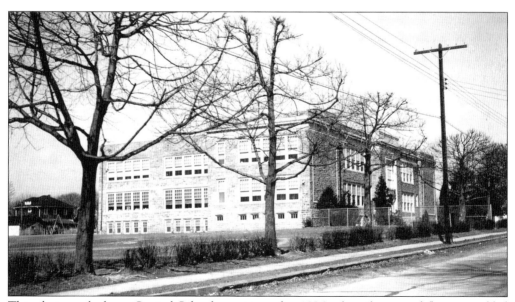

This photograph shows Central School sometime after 1926, when the second floor was added and the courtyard was replaced with an auditorium and basement. Edythe Collins was the principal until 1953. The school was razed in 1978 to make room for athletic fields. (J. Garoh Jr.)

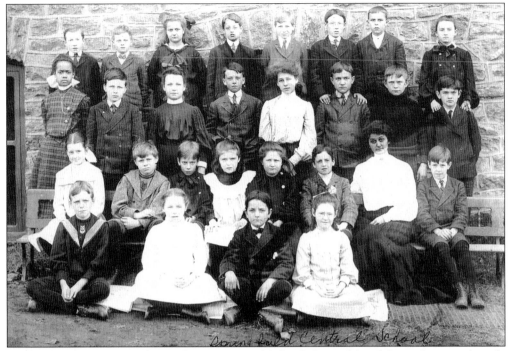

Pictured here is the 1921 class at the new Central School. Central faced Saxer Avenue, directly across from the firehouse. Identified are Joseph Lownes (second row, second from the left) and teacher Miss Fudge (second row, second from the right). (Jane Lownes Shea.)

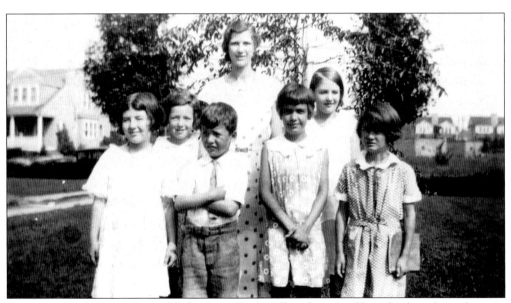

Posing on the lawn of Central School are Ruth Till and some of her third-grade students in 1933. In the front row are, from left to right, Peggy Carlisle, Dick Cassel, Betty Harris, and Susan Bien. The house on the left is 210 Powell Road. (Phoebe Jane Harris.)

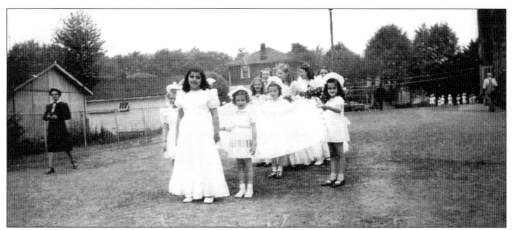

The first May Day celebration at Central School was held in 1948. Angie Ruggierio (foreground) was chosen as the May queen. Her attendants were Marilyn Pugsley, Nancy vonGlahn, Christine Herman, Thelma Tatum, Bette Denice, Judy Schaub, Mary Davis, and Nancy Stitchler. Train bearers were Joan Madison, Carol Jump, Nancy Hoehl, Judith Hedl, and Leslie Lee White. The dresses were made by the girls' mothers. (Angie Ruggierio Corrao.)

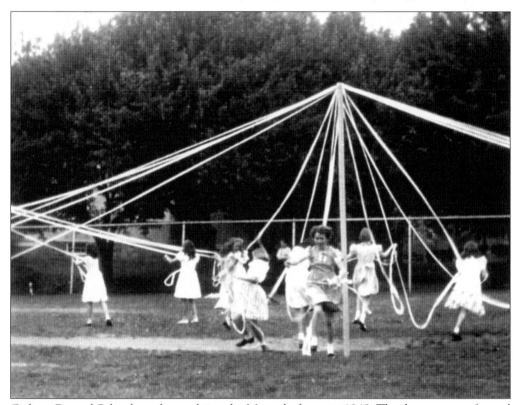

Girls at Central School are shown doing the Maypole dance in 1948. The dance was performed around a tall pole with many streamers attached to the top. Holding her streamer, each girl wove a pattern by going over and under others' streamers. The girls then reversed the dance and ended with the streamers straight once again. All of the students enjoyed this day of fun and games. (Angie Ruggierio Corrao.)

103

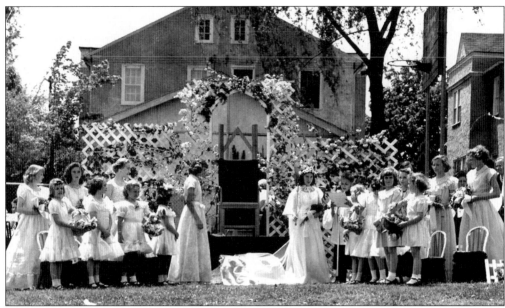

Mary Ann Light was crowned May queen at Central School in May 1950. Attendants were Gail Artley, Kitty Irving, Shirley Palmer, Norma Phillips, Ingrid Reiniger, Myra Wardell, and Joan White. Randy Wilson was the court counselor, and girls in the court were Joan Paul, Linda Hutchinson, Sally Stalher, Karen Pearson, Joan Fitch, Gail Knapp, Barbara Mainwaring, and Betty Lou Kelican. The houses in the background are located on Franklin Avenue. (Phyllis Rohrer Sheely.)

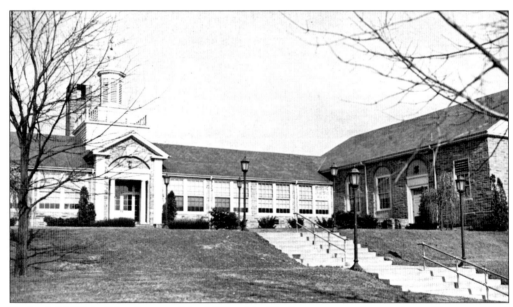

Springfield High School opened in 1931 with 13 classrooms and a total enrollment of 790 students. Harvey Sabold served as the supervising principal. The first graduating class, in 1935, consisted of 57 students. Prior to 1931, students could attend Swarthmore, Media, or Lansdowne High Schools. Pictured on opening day, this Springfield High School was destroyed by a fire in 1977. (Springfield Historical Society.)

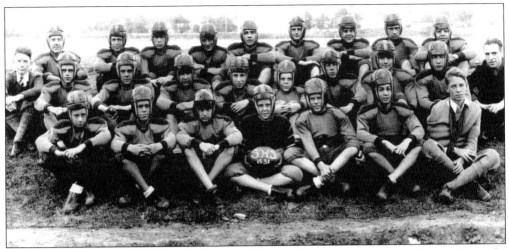

Shown here are members of the 1931 Springfield High School football team. From left to right are the following: (first row) B. Kelso, J. McCullough, P. Mason, P. Mowrer, D. Weightman, J. Beggs, and H. Smith (with a broken arm); (second row) J. Owens, H. Gallager, L. Carlston, J. McKenna, A. McConnell, R. Goheen, J. Carroll, B. Thomas, J. Wilson, and coach W. Schopf; (third row) H. Merrill, B. Wood, L. Mason, J. Kennedy, K. Chandor, E. Spangenburg, W. Goheen, T. Seth, and B. Fisher. (Eileen Mowrer.)

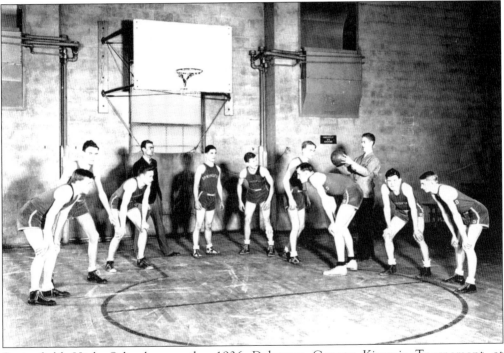

Springfield High School won the 1936 Delaware County Kiwanis Tournament at Pennsylvania Military College (now Widener University), beating 19 competing high schools. In the high school gymnasium, from left to right, are Joe Carroll, Chic Crothers, captain Don Weltmer, coach Willis Stetson, Sam Warburton, Don Weightman, Curwin Schlosser, manager Phil Mowrer (with the ball), Jim Kennedy, Huey Bathgate, and Charlie Marker. (Eileen Mowrer.)

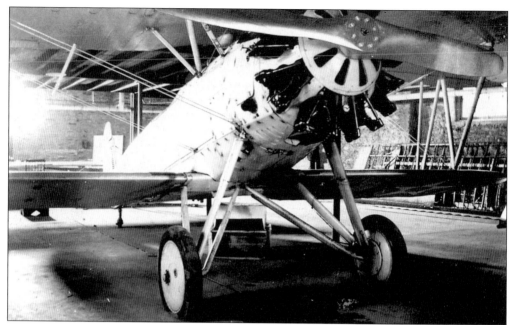

In December 1935, the Springfield Aviation Club met at the high school with instructor Walter Appleby, a U.S. transport flyer. Appleby made arrangements to obtain a surplus World War I military plane. The plane was housed in the basement of Springfield High School, under the auditorium. It was recalled for active service during World War II as a trainer. (Harry Bornman.)

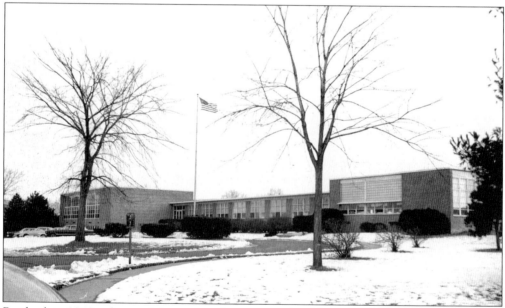

By the late 1940s, the need for a new elementary school became clear. The district started construction in 1950 and dedicated the new school in 1951. Scenic Hills was a state of the art school at the time, with 14 classrooms opening directly onto the outside playground. The spacious design included a modern kitchen and a basement playroom. The school celebrated its 50th anniversary in 2001. (Springfield Historical Society.)

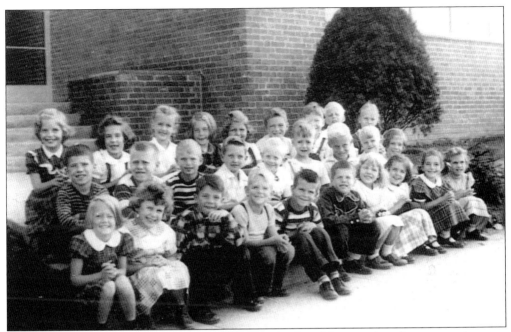

Pictured here is Miss Barnes's 1951–1952 first-grade class. Many smiling faces grace the steps leading to the new Scenic Hills School, including that of Johanna Duffy (third row, third from the left). Edna M. Renuf was the first principal of the school. Renovations in 1956 included a library, which was provided by the mothers of the students enrolled at that time. (Springfield Historical Society.)

Dedicated in November 1955, Sabold School is located on a 13-acre tract of land on Thomson Avenue. The school was named for Harvey C. Sabold, who served as supervising principal of the school district from 1921 to 1951. In 1969, a learning materials center and kindergarten were added. (Springfield Historical Society.)

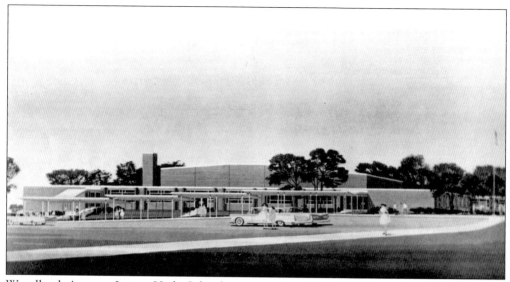

Woodland Avenue Junior High School was completed in 1962 for grades six and seven. In 1975, grade five was added and, shortly thereafter, grade eight, making it a middle school. In 1976, the name was changed to E. T. Richardson Middle School, honoring E. T. Richardson's 41 years of service to the school district. (Springfield Historical Society.)

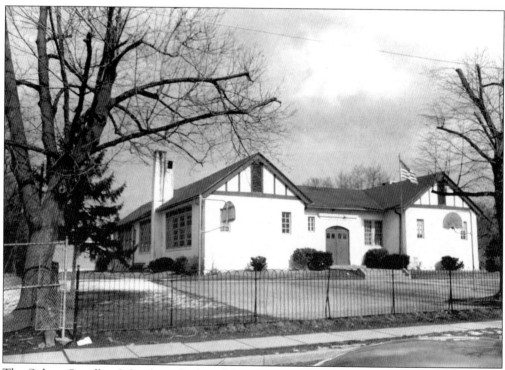

The Sidney Smedley School was built in Morton in 1914. It closed in June 1979. Today, the building serves as the Morton Borough Hall. (Keith Lockhart.)

Seven
PLACES OF WORSHIP

Samuel and Albert Evans share thoughts on the lawn of the Springfield Friends Meeting House in 1910. Meetings were first held in the home of Bartholomew Coppock Jr., who donated the land for the Friends Meeting in 1686. The meetinghouse was constructed in 1701 but burned in 1737. It was rebuilt and used continuously until 1851, when the current building was constructed. (Springfield Historical Society.)

In 1835, the Society of Friends erected this wood-frame building adjacent to the meetinghouse at the corner of Springfield and Old Sproul Roads. Originally used as a school and library for the congregation, it now serves as the caretaker's residence. (Springfield Historical Society.)

Located on Baltimore Pike, the Lownes Free Church was built of native blue limestone by George Bolton Lownes in 1832. The Blue Church, as it became known, was used by all denominations free of charge. George Bolton Lownes died two years after the construction of the church and is buried on the grounds. (Delaware County Historical Society.)

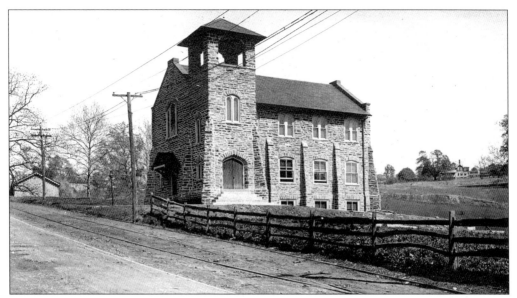

Victoria Union Chapel was built in 1914 as an undenominational church. The Turner family owned the Victoria Plush Mills and donated the church site property on Baltimore Pike. Trolley tracks are visible in this 1914 view. The Lansdowne Construction Company used local stone quarried by residents of the Plush Mills village to build the church. In 1958, the name was changed to Victoria Baptist Church. (Sarah Bewley Rann.)

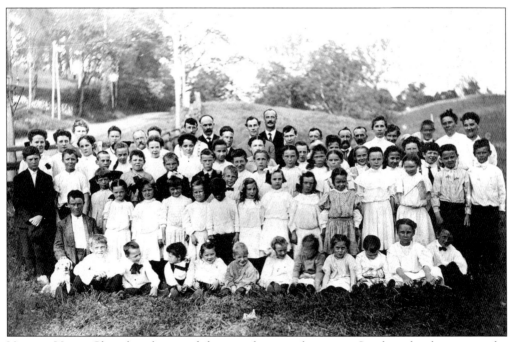

Victoria Union Chapel students and their teachers are shown at a Sunday school picnic on the grounds of the Victoria Village in 1920. Parents of these children worked at the Plush Mills and resided in the village. The children attended Oakdale Public School on Baltimore Pike, just east of Sproul Road. (Sarah Bewley Rann.)

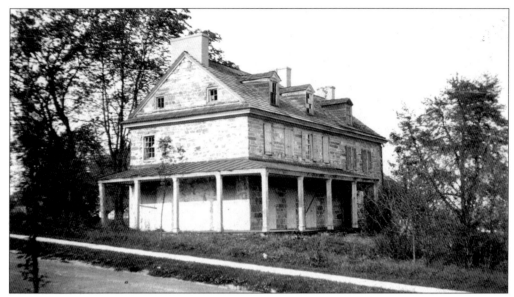

This farmhouse, located at the corner of Summit and Cascade Roads, was once owned by the Mayer family. In 1924, it housed the First Presbyterian Church. In 1928, it was enlarged to increase the size of the sanctuary. Eventually, it was razed to make way for a permanent church. (Keith Lockhart.)

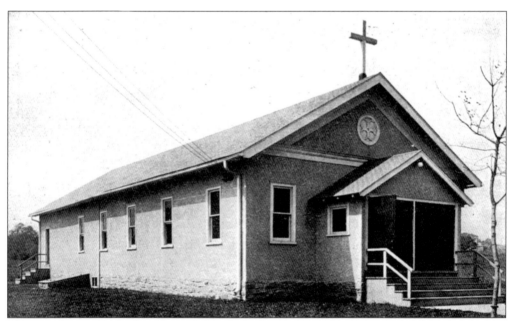

The St. Francis Chapel was erected in September 1923 on property purchased from the Johnston family, whose farmhouse was located across from South Rolling Road on Saxer Avenue. Father Conway, the first pastor of St. Francis, celebrated the first Mass in the Johnston farmhouse in June 1923. Today, this building is located in the rear parking lot of St. Francis Church and is known as Conway Hall. (Keith Lockhart.)

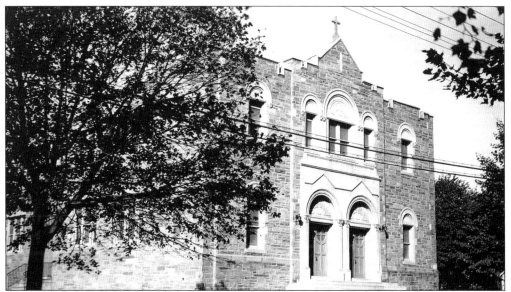

In 1929, under Rev. Nicholas Travo, St. Francis Church completed a new sanctuary at the corner of Saxer Avenue and Lownes Lane. It was built as a combination, with the church on the ground floor and the parish school on the second floor. As St. Francis continued to grow, the whole building became the parish school and a new church was completed in November 1952. (Bill Campbell.)

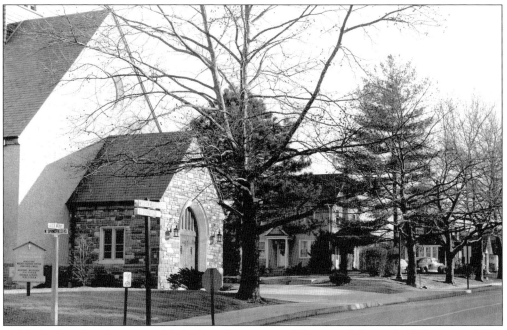

A Methodist church was established at the corner of Saxer and Springfield Roads in 1922. During an expansion, a surplus army building was erected and used until the wing was completed in 1957. A name change in 1968 gave the community Covenant United Methodist Church, and one year later, the fellowship and education building was added. (Springfield Historical Society.)

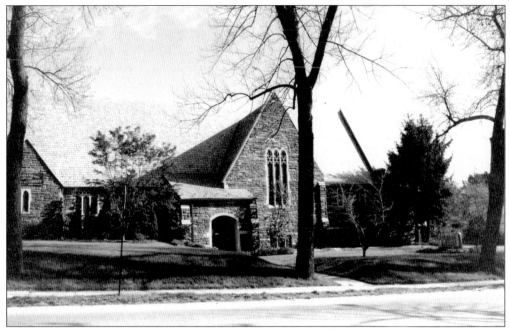

The Episcopal Church of the Redeemer was established in May 1924. The church, located at the corner of Springfield and Hillcrest Roads, was dedicated in June 1929. With its exquisite stone and slate roof detailing, the church remains standing today. (Evelyn Thomas.)

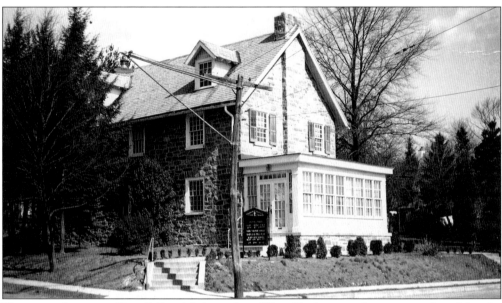

This stone home on Powell Road belonged to Ellen Hackett until it was purchased by the Church of Christ in 1930. Rev. Gentry founded the congregation in 1928 and held early services in Old Central School and the firehouse. (Springfield Historical Society.)

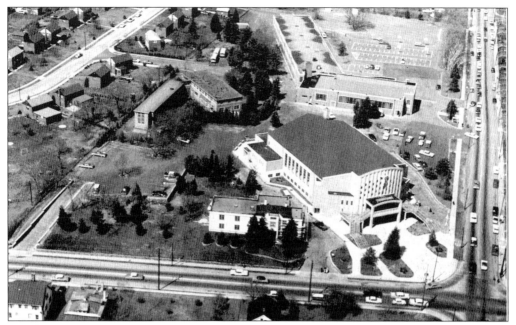

On the corner of Springfield and Bishop Roads stands the Holy Cross Catholic Church on what was the Anderson Nursery property. Completed in 1966, the church has marble railings and ornamental iron work from the old Mastbaum Theatre in Philadelphia. (Springfield Historical Society.)

The Springfield Baptist Church is located on the corner of Norwinden Drive and Valley View Road. It was established in 1951 and dedicated in 1954. (Evelyn Thomas.)

A struggling Lutheran church that began in 1848 in Philadelphia was relocated to Springfield in 1952. It retained the original name of St. John's Lutheran Church (Missouri Synod). Early services were held in the Central School auditorium until the church, pictured here, was completed on Scenic Road. (Evelyn Thomas.)

The Princeton Presbyterian Church, located at Church Road and Baltimore Pike, was founded in 1853 in Philadelphia. It remained there until its relocation to Springfield in 1953. Sunday school classes were held at the Keystone School of Business, next-door, until completion of the church. (Evelyn Thomas.)

In 1942, during World War II, the St. Matthew Lutheran church was established by Rev. Donald Doll. Early services were held in the old township building. War restrictions on building materials held off completion of the church until 1944. The first church-sponsored kindergarten in Springfield was established here in 1952. (Evelyn Thomas.)

St. Kevin's Church was built in 1958 on the west side of Sproul Road at Thomson Avenue on the original Lownes property, with the rectory located in the historic Lownes Home. (Evelyn Thomas.)

C. C. Hancock United Methodist Church was built in 1957, honoring the name of a church founded in Philadelphia many years earlier. It is located on the west side of Sproul Road at Beatty Road. (Evelyn Thomas.)

Organized in 1954 with 25 families, Congregation Nel Tamid was located at 300 West Woodland Avenue. It was built on land donated by D. and N. Stott and E. J. Walsh. First meetings were held in the Morton and Clifton firehouses until construction was complete in 1961. (Evelyn Thomas.)

Eight

FROM FARMS
TO SUBURBIA

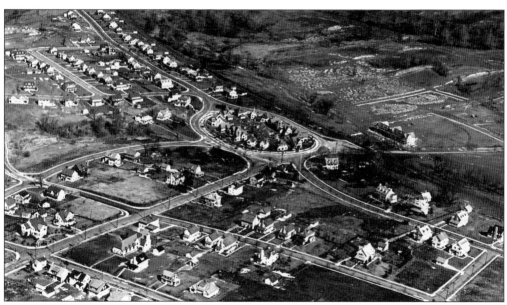

This June 1926 aerial view of Windsor Circle shows the 2.9-acre oval development just after completion. Windsor Circle was designed by Philadelphia architects MacKenzie and Willey in an Elizabethan or late-Tudor style. Surrounded by a brick-capped stone wall with covered gateways leading walks to home fronts, this development was inspired by the English mews. Exteriors were constructed of brick or heavily textured masonry with half timbering, casement windows, and English style roof tiles. The Red Arrow Trolley Line crosses Springfield Road just above the development. (Hagley Museum.)

Pictured here in 1915 on a knoll at the intersection of South Rolling and Springfield Roads is the former Springfield Real Estate Company building. When the real estate office was vacated, Robert Alexander established the first free library of Springfield here in the late 1920s. The building was rent free, and the books were all donated. Today, the building is a private residence, at 100 Springfield Road. (Springfield Historical Society.)

This home was built in 1917 at 219 North Rolling Road. The original owners were Charles and Edna Cope. The Springfield Real Estate Company started this development in 1915, with house prices ranging from $7,000 to $8,000. (Leslie Masson.)

This 1924 photograph shows some of the new houses built at Rolling and Summit Roads. Windsor Circle is in the foreground. The Springfield Real Estate Company developed this area, in which the prices of the homes ranged from $5,825 to $7,975. (Keith Lockhart.)

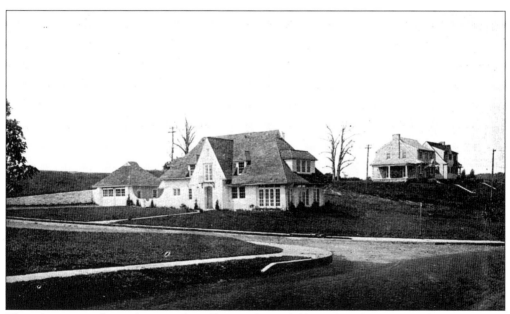

These houses are located at North Rolling and Overhill Roads. They are another part of the Springfield Real Estate Company's 1924 development. The Media Short Line Trolley was a big factor in the sale of these houses because it provided convenient transportation from the city to Springfield. (Keith Lockhart.)

This view shows the Springfield Road Trolley Station (right) and two stores on Brookside Road. The stores were built in 1924 as the Springfield Real Estate Company was developing new homes on Rolling, Summit, and Overhill Roads. Today, the stores are occupied by Hair by Michael and the Instrument Works (left) and Dr. Robert Shusman's office (center). (Keith Lockhart.)

Brand-new twin houses line the 300 block of Powell Road in 1924. Powell was still a dirt road at the time, although it did not remain so for much longer. Note the mailboxes along the road. (Keith Lockhart.)

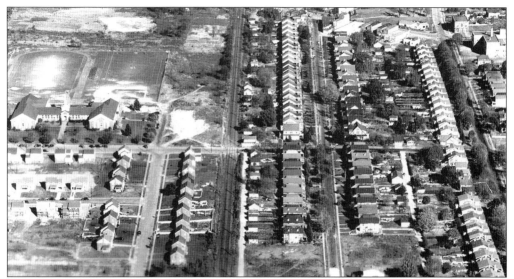

Looking north from State Road, this view shows new homes on Weymouth, Hempstead, Northcroft, Southcroft, Stanfield, Maris, and West Rolling Roads and Rutherford Drive in 1954. George Rutherford sold this farmland, which was part of the original 1722 Maris Home House farm. The original farmhouse is pictured in the lower right, on the north side of State Road. Rolling Green Country Club and Golf Course borders the new development. (John R. Curtis Collection.)

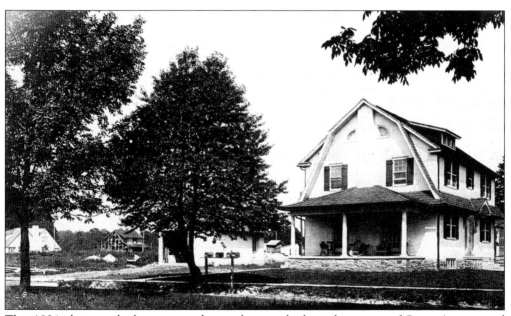

This 1924 photograph shows a new house that was built at the corner of Saxer Avenue and Baltimore Pike as part of the Springfield Gardens development. The Le Hann Circle houses are being built to the left. Today, with the porch enclosed, this house is the site of Delaware Valley Appliance. (Springfield Historical Society.)

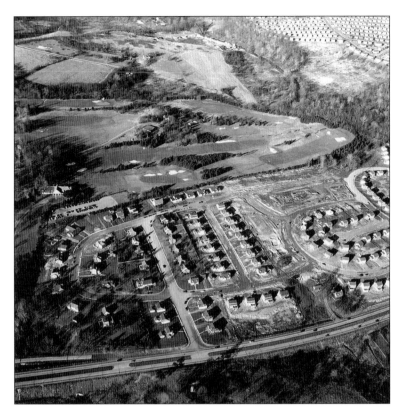

Pictured in the early 1940s, these new homes are part of the Joseph Mozino development on Leamy, South Rolling, and Thornridge Roads. Springfield High School is in the left center, and St. Francis Church and School are in the upper left. The houses on Wyndmoor and Wayfield Roads and Woodland Avenue were completed later. Notice that South Rolling Road has not yet been built between Leamy and Saxer Avenues. (Don Burke.)

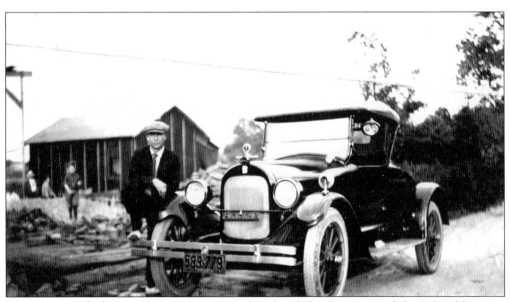

This photograph shows Thomas Masson standing beside his fine automobile. Behind him is a single-story structure that he built as a temporary home for his family while he constructed his house on the next lot over, at 247 Saxer Avenue. (Edgar Masson.)

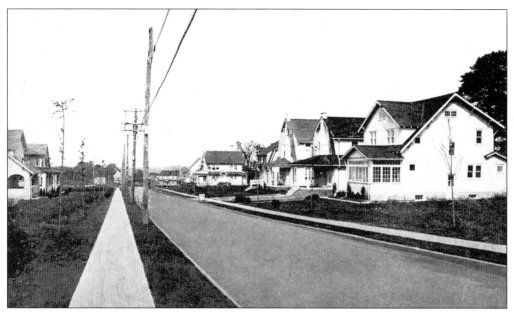

This 1924 picture shows Forest Road as part of the Springfield Farms development, which included Mansion, Orchard, and Shelburne Roads. Many areas of Springfield Township were developed after World War II, including Stoney Creek and Colonial Park in the late 1940s and Scenic Hills in the early 1950s. (Keith Lockhart.)

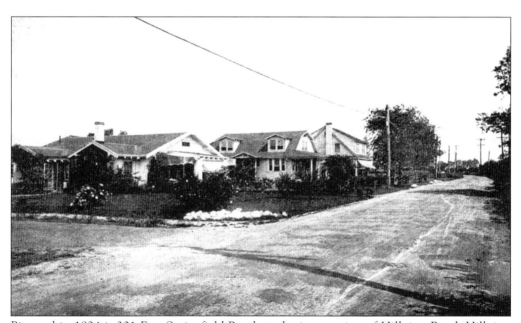

Pictured in 1924 is 301 East Springfield Road, at the intersection of Hillview Road. Hillview was only a proposed street and never was cut through to Springfield Road. It is used as a driveway today. (Don Burke.)

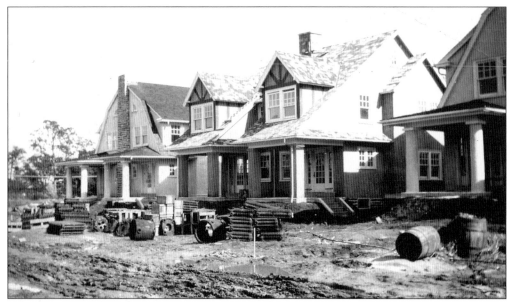

In 1925, construction began on twin homes in the 200 block of Ballymore Road. They were built in a series of six. During the Depression and even into the early 1940s, the price of these homes dropped to as low as $3,500 to $4,000. This property was formerly part of the Johnston Farm. (Springfield Historical Society.)

This photograph shows Harry Bornman's home, at 253 Saxer Avenue, in 1936. This is a Sears home, which was ordered directly from the Sears Catalog. Instructions, lumber, nails, shingles, paint, and all other necessary materials were included in the shipment. There are many Sears homes scattered throughout Springfield today. This house was demolished in 1982 to make way for a new home. (Harry Bornman.)

This two-story brick house was built at 336 Hawarden Road for the Aikman family in 1941. The first house on the street, it stood alone until the development of Colonial Park began after the end of World War II. (Bud Aikman.)

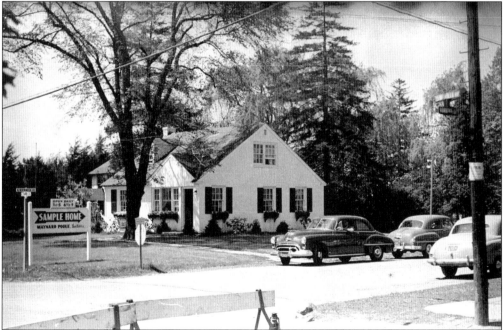

This sample home for the Springfield Manor development was built at the corner of Springfield Road and Norwinden Drive. Maynard Poole was the builder of these masonry bungalows during the 1950s. The homes included four bedrooms and one or two bathrooms. (Kathleen Patenaude.)

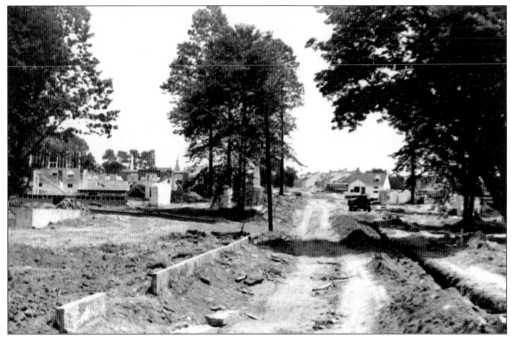

Pictured in this photograph is the 200 block of Wayne Avenue under construction in the late 1940s or early 1950s. Springfield was growing rapidly at the time, and Cape Cod–style homes, like the one seen in the background, sold quickly. (Kathleen Patenaude.)

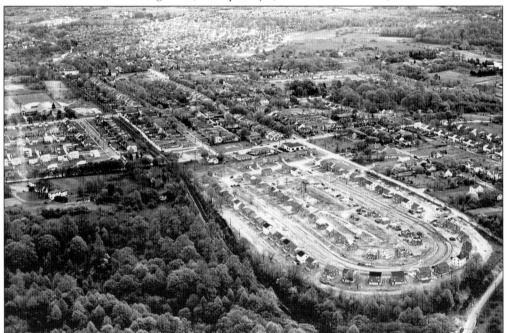

Looking east, this 1950 aerial view shows the horseshoe-shaped housing development that included Briarhill, Wheatsheaf, Bryant, and White Oak Roads. Woodland Avenue bisects the photograph. At the corner of Powell Road and Woodland Avenue was the Ford dealership, with a row of shops stretching down to the trolley line. (Media Historical Society.)